BUILDING FOR THE FUTURE

a photo journal of

Saskatchewan's Legislative Building

BUILDING FOR THE FUTURE

a photo journal of
Saskatchewan's Legislative Building

by

Gordon L. Barnhart

additional research and photo selection by

David McLennan

CANADIAN PLAINS RESEARCH CENTER 2002

UNIVERSITY OF
REGINA

Copyright © 2002 Canadian Plains Research Center, University of Regina

Copyright Notice
All rights reserved. No part of this work covered by the copyrights hereon may be reproduced or used in any form or by any means—graphic, electronic, or mechanical—without the prior written permission of the publisher. Any request for photocopying, recording, taping or placement in information storage and retrieval systems of any part of this book shall be directed in writing to the Canadian Reprography Collective.

Canadian Plains Research Center
University of Regina
Regina, Saskatchewan S4S 0A2
Canada
Tel: (306) 585-4758
Fax: (306) 585-4699
e-mail: canadian.plains@uregina.ca
http://www.cprc.ca

National Library of Canada Cataloguing in Publication Data

Barnhart, Gordon Leslie
 Building for the future

(Trade books based in scholarship)
ISBN 0-88977-145-6

1. Legislative Building (Regina, Sask.)–History–Pictorial works. 2. Historic buildings–Saskatchewan–Regina.
3. Regina (Sask.)–Buildings, structures, etc. I. University of Regina. Canadian Plains Research Center. II. Title.
FC3546.8.L43B37 2002 971.24'45 C2002-910788-1
F1074.5.R3B37 2002

Layout and Design: David McLennan and Donna Achtzehner
Cover Design: Brian Danchuk

Digitally enhanced photos (colourized photos on pages 35 and 41, retouched photo on page 58 and repaired photo on page 91) are by Brent Pylot, Epic Art Enhancement, Regina.

Printed and bound in Canada by Houghton Boston, Saskatoon, Saskatchewan

Printed on acid-free paper

To Elaine—my wife and partner—in appreciation for her support and companionship.

To David—our son—who when he was a young lad used to point to the Legislative Building with pride and exclaim: "There's my Dad's office!"

To Sarah—our daughter—who as a child loved swimming in the pool and picnicking in the park across the lake from the Legislative Building.

To all three, I give my thanks for their support and patience when I worked in the Legislative Building as the Clerk of the Legislature. We have many happy memories of this building.

Table of Contents

Preface

When approaching from the west, visitors to Regina are able to see the city skyline from a distance of some sixteen miles. In the southern section of the city, standing alone and towering above the surrounding buildings, is the dome of the Saskatchewan Legislative Building. For nearly one hundred years, this monument has withstood the tests of time, weather and even political storms, and has maintained its beauty and grandeur.

The Legislative Building was not designed to be just any ordinary structure. Rather, it was to be a symbol of the confidence and vision that the early pioneers had for their new province—a monument to democracy. As the centenary of Saskatchewan's formation as a province approaches, this is perhaps an appropriate time to reflect on the significant role that the Legislative Building has played in our history as a province and as a people.

To enter the building fills one with a sense of the past, knowing that many of the most important debates and decisions in Saskatchewan's history took place in either the legislative chamber or the executive suite. One can imagine the many people who walked the corridors or climbed the stairs, carrying with them the heavy burden of office. The building has also been a centre for many of the province's most important events, ranging from royal visits to demonstrations over issues such as labour disputes, Medicare, privatization, and the farm crisis. People wanting to gain the attention of the government or the media could do so by staging a demonstration in front of the building or within the rotunda.

The Legislative Building and its surrounding park have also become a social and sport centre for people to walk, jog, play football, or just visit with friends on the lawns. The green area surrounding the building is one of the largest urban parks in Canada and is home to a wide variety of birds.

The Legislative Building has special meaning for me and my family as well, for I worked there for twenty years as Clerk of the Legislative Assembly. Throughout that time, I never lost my sense of awe and admiration for the visionaries, architects, and workers who designed and built such a magnificent edifice. While walking down its halls, I would often see a sculpture, design, or gargoyle that I had not noticed before and would marvel anew at the intricate detail of the building and its furnishings.

During my tenure as Clerk, my family would often entertain visitors to the city, and every tour of the city with our guests would invariably include a visit to Wascana Park. As we passed the Legislative Building during these tours, our young son would exclaim with pride: "There's my Dad's office!"

SAB 81-1195-152

This sense of pride, which is shared by so many of the people of this province, ultimately prompted me to write this book. Some of the photos contained herein were first collected when I published "Sentinel of the Prairies," a pictorial history of the Legislative Building. The text came from research done for a series of newspaper articles that were published at the time of the seventy-fifth anniversary of the building's opening in 1987. Research done for my biography of Walter Scott, Saskatchewan's first premier, also contributed to the writing of this book.

I want to express my thanks to Mr. Don Graves, who as a researcher for the Legislative Assembly in 1975 compiled a list of many of the records and photos related to the design and construction of the building and who wrote a guide for other researchers to follow. Thanks as well must go to the hard-working and loyal staff at the Legislative Library and the Saskatchewan Archives Board. Without the records and photos, a book such as this would have been impossible. The staff at the Saskatchewan Property Management Corporation are to be commended for having designed a web site documenting the recent renovation and restoration of the building, together with a collection of photos and vignettes. All of these researchers, librarians, archivists, architects, and construction workers share a common bond to the Saskatchewan Legislative Building.

I want to thank the Canadian Plains Research Center and in particular, Brian Mlazgar, editor, David McLennan, research, photo selection and layout, Donna Achtzehner, layout, and Anne Pennylegion, publicity. This is a hard working and professional team, all of whom admire the Legislative Building and believe in this project. I wish to extend special thanks to Don Hall and David McLennan who took many of the modern photographs for this book.

Last, but not least, we must recognize the contribution of the political figures throughout the history of our province who had the foresight and wisdom to plan, design, construct, and maintain a building of such beauty and importance, for their own time and for future generations. In the words of Premier Walter Scott—"This is a great country. It needs big men with large ideas." The Legislative Building is an outstanding example of the "large ideas" that helped to build this province.

Gordon L. Barnhart
June 2002

Acknowledgements

Ryan Arnott, Saskatchewan Arts Board

Steve Bata, Building Supervisor, Saskatchewan Legislative Building

Debra Brin, Editor, Briarpatch Magazine

Wendy Campbell, Director of Communications, Culture, Youth and Recreation

Lorraine deMontigny, Director of Visitor Services, Legislative Building

Ella Denzin, Assistant Manager, Government House Heritage Property

Dr. Michael Jackson, Executive Director, Protocol Office

Julie Korman, Assistant Curator, John Bland Canadian Architecture Collection, McGill University

Arnold McKenzie, Senior Guide, Visitor Services, Legislative Building

Marianne Morgan, Visitor Services, Legislative Building

Tim Novak, Saskatchewan Archives Board

Todd Radenbaugh, Department of Geology, University of Regina

Maurice E. Riou, Office of the Sergeant-at-Arms, Legislative Assembly

Carl Shiels, Executive Director & Registrar, Saskatchewan Land Surveyors' Association

Nadine Sisk and Lynette Piper, Saskatchewan Property Management Corporation

Jeff Tocher, Assistant Building Supervisor, Legislative Building

University of Regina Archives

BUILDING FOR THE FUTURE

Foundations of Democracy

"These are the gardens of the desert; these the unshorn fields boundless and beautiful, for which the speech of England has no name—the Prairies."

—*William Cullen Bryant*

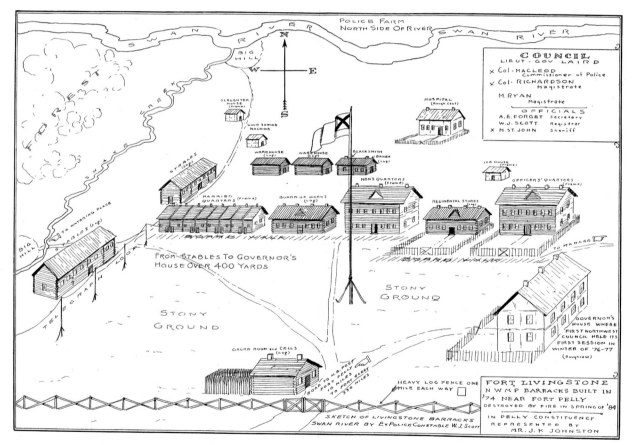

FORT LIVINGSTONE: The North-West Territories' first Territorial Council met March 8, 1877 at Fort Livingstone, located south of the Swan River, north of present-day Pelly, Saskatchewan. The drawing above by W.J. Scott (the Territorial Council registrar) shows the layout of the fort, which burned down in the spring of 1884. The governor's house, where the Territorial Council met, is the building at lower right.

Prior to the creation of Saskatchewan in 1905, British immigrants had brought the tradition of parliamentary democracy to the North-West Territories. Although government in the region was originally in the hands of the lieutenant governor, as time passed the settlers lobbied for—and won—elected, representative, and responsible government in the West.

The seat of government in what is now Saskatchewan changed several times over the years. The first Territorial Council met in 1877 at Fort Livingstone, an outpost of the North-West Mounted Police. The following year, the Council met at the Lieutenant Governor's residence in Fort Battleford, the new territorial capital. Following the arrival of the Canadian Pacific Railway, the capital of the North-West Territories was moved in 1883 from Battleford to Regina, and the Territorial Council (soon to be called the Territorial Legislative Assembly) met in the Government Buildings on Dewdney Avenue. In 1888, the creation of the Legislative Assembly meant that all members were now elected, rather than being appointed, and a Speaker was chosen to preside over Assembly meetings rather than the Lieutenant Governor, as had hitherto been the case.

NORTH-WEST TERRITORIES: The map right shows the Districts of Saskatchewan and Assiniboia and the communities which were (or were considered for) the seat of government in the pre-1905 era.

DISTRICT OF SASKATCHEWAN

Battleford •

Ft. Livingstone •

DISTRICT OF ASSINIBOIA

• Fort Qu'Appelle

• Regina

SAB R-B 48 (1)

Doesn't your Excellency detect a Bad Odour about this Pile of Bones?

TO FORT QU'APPELLE THE NATURAL CAPITAL OF ASSINIBOIA

THE GOVERNOR-GENERAL TRANSFORMING PILE OF BONES INTO REGINA, CAPITAL OF ASSINOBIA.

SAB R-A 2494

GOVERNMENT HOUSE, BATTLEFORD: The North-West Territorial Council met in Government House, Battleford (left) from 1878 until the relocation of the capital to Regina in 1883. The decision for the move, made by Lieutenant Governor Edgar Dewdney (1835–1916) (inset left), stirred considerable controversy across the country. The satirical cartoon above, which appeared in *Grip*, a Toronto weekly, depicts Canada's Governor General pouring a scent on "Pile of Bones" to transform it into "Regina." Dewdney is standing with his back turned. The signpost at top right points to "Fort Qu'Appelle, the natural capital of Assiniboia."

NORTH BATTLEFORD NHP LIBRARY

3

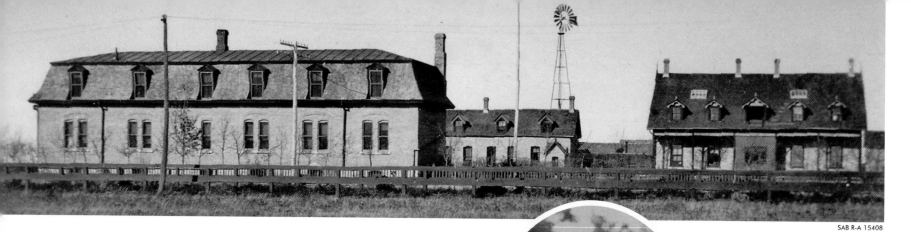

SAB R-A 15408

TERRITORIAL GOVERNMENT BUILDINGS, REGINA: Located on Dewdney Avenue about a mile west of the town on the open prairie, the Territorial Government Buildings (above) included, from left to right, the Administration Building, the Legislative Building, and the Indian Office. The Administration Building still stands at the corner of Dewdney Avenue and Montague Street.

NORTH-WEST COUNCIL IN SESSION, 1884: Presiding at the head of the table (below) is Lieutenant Governor Dewdney. At the small table on the right is Amédée Emmanuel Forget, Dewdney's private secretary, clerk of the council, and the future Lieutenant Governor of the Province of Saskatchewan. Forget (1847–1923) is pictured right with his pet monkey "Jocko," circa 1910. Also beginning a long career in public service is the council's page, ten-year-old James McAra (seated far left). He would become Regina's mayor from 1927 to 1930, and again from 1932 to 1933. Politics, it seems, ran in the McAra family's blood—James' brother, Peter McAra, was also the mayor of the city, in 1906, 1911, and 1912.

SAB R-A 7593

On September 1, 1905, the provinces of Alberta and Saskatchewan were carved out of the vast North-West Territories. Saskatchewan, with Regina as the capital, had a population of approximately 250,000, composed of Europeans, Métis, and Aboriginal peoples, spread over a land mass of one-quarter million square miles. Despite these humble beginnings, the early settlers were not thinking only of the present—their eyes were fixed on the future as well. Many believed that one day Saskatchewan would be the wealthiest, most populated, and most important province in Canada. In the words of Walter Scott, Saskatchewan's first premier:

> *This province has as yet less than half a million souls and there is plenty of room for at least ten millions. Just as sure as the sun shines there will be within this Province alone some day a population running into the tens of millions.*

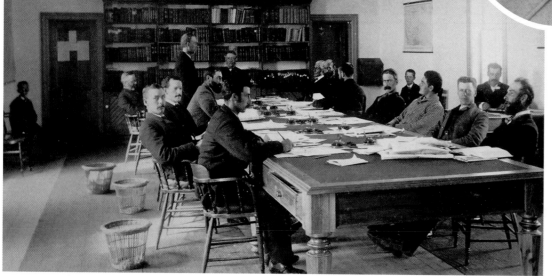

SAB R-B 490

THE LEADER.

VOL. 22—NO. 29.　　　REGINA, N.W.T., WEDNESDAY, SEPTEMBER 6, 1905.　　　PRICE FIVE CENTS.

HAIL PROVINCE OF SASKATCHEWAN!

New Province Enters Confederation Under Happy Auspices---Brilliant and Spectacular Scenes---Imposing Military Review---Lieutenant Governor Sworn In---Civic Addresses Presented to the Governor-General and Lieutenant-Governor---Luncheons and State Dinner---Grand Display of Fireworks---Dazzling Illuminations---State Ball

HIS HONOR GEORGE HEDLEY VICARS BULYEA
Sworn in September 1st as First Lieutenant-Governor of Alberta

Officially Created September 1. 1905

THEIR EXCELLENCIES THE GOVERNOR-GENERAL AND LADY GREY
Who Honored the Inauguration Ceremonies With Their Presence Last Monday

Formally Inaugurated at Regina September 4, 1905

HIS HONOR AMÉDÉE EMMANUEL FORGET
Lent Lieut.-Gov. of North-West Territories, Sworn in Sept. 4, as First Lieutenant-Governor of Saskatchewan

THE CREATION OF A PROVINCE: *The Leader* announces a new province (above). The Saskatchewan Act was passed by the House of Commons in Ottawa on July 5, 1905. After receiving Senate approval and royal assent, Saskatchewan became a province, as did Alberta, on September 1. In Regina, the inauguration ceremonies took place on September 4, with Prime Minister Wilfrid Laurier, Governor General and Lady Grey (pictured centre) attending the ceremonies. Amédée Emmanuel Forget (right) was sworn in as the province's first lieutenant governor. George H.V. Bulyea (left) took the oath of office in Alberta.

INAUGURATION PARADE, REGINA, SEPTEMBER 4, 1905: The procession marched under celebratory arches on South Railway (now Saskatchewan Drive), passing the Regina Trading Company on the corner of Scarth Street and South Railway.

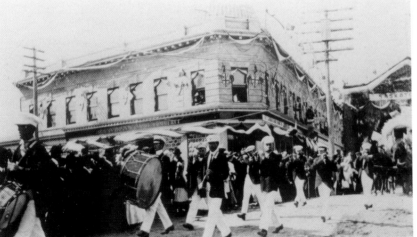

SAB R-B 8339

SAB R-A 2747 (1)

5

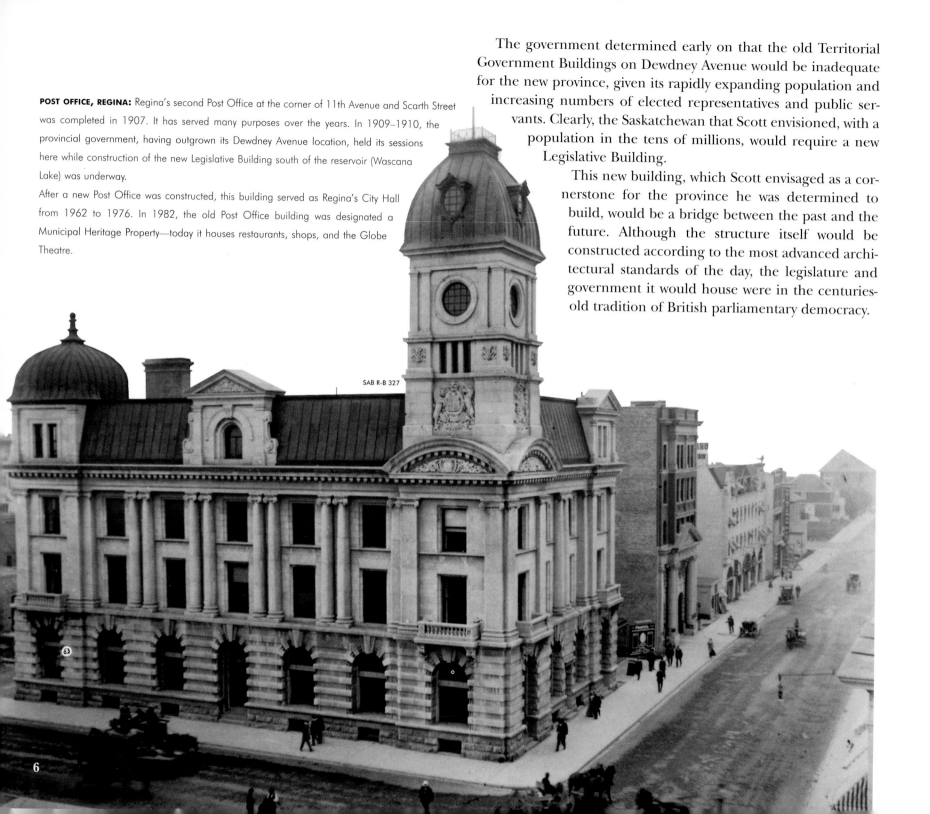

POST OFFICE, REGINA: Regina's second Post Office at the corner of 11th Avenue and Scarth Street was completed in 1907. It has served many purposes over the years. In 1909–1910, the provincial government, having outgrown its Dewdney Avenue location, held its sessions here while construction of the new Legislative Building south of the reservoir (Wascana Lake) was underway.

After a new Post Office was constructed, this building served as Regina's City Hall from 1962 to 1976. In 1982, the old Post Office building was designated a Municipal Heritage Property—today it houses restaurants, shops, and the Globe Theatre.

SAB R-B 327

The government determined early on that the old Territorial Government Buildings on Dewdney Avenue would be inadequate for the new province, given its rapidly expanding population and increasing numbers of elected representatives and public servants. Clearly, the Saskatchewan that Scott envisioned, with a population in the tens of millions, would require a new Legislative Building.

This new building, which Scott envisaged as a cornerstone for the province he was determined to build, would be a bridge between the past and the future. Although the structure itself would be constructed according to the most advanced architectural standards of the day, the legislature and government it would house were in the centuries-old tradition of British parliamentary democracy.

T. Walter Scott, Premier and Visionary

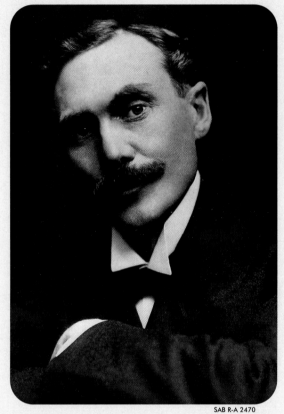

SAB R-A 2470

Thomas Walter Scott was born on October 27, 1867, the year of Canadian Confederation, on a farm halfway between London and Strathroy, Ontario. Scott received a grade eight education before moving West in 1885 to farm with his uncle near Portage La Prairie. Due to the North-West Resistance in that year, Scott's plans to farm did not materialize and instead he worked for C.J. Atkinson, owner and editor of the *Manitoba Liberal*. By 1886, Scott followed Atkinson to Regina to work at the *Journal*, a Regina newspaper. He soon branched off on his own and went into part-ownership of the *Standard*; in 1894, he bought the *Moose Jaw Times*, and the following year he expanded his printing empire by buying the *Regina Leader* from Nicholas Flood Davin.

Scott married Jessie Read in 1890 and became involved in local politics through the influence of two Liberals, C.J. Atkinson and Jim Ross. By 1900, Scott was elected as the Member of Parliament for Assiniboia West, defeating the incumbent, Davin. He served in Parliament in the Laurier Administration and played an active role in the negotiations that led to the formation of Alberta and Saskatchewan on September 1, 1905. In August of that year, Scott became leader of the provincial Liberal Party and at age 38 was appointed Premier on September 5, 1905 by Lieutenant Governor A.E. Forget. Scott's premiership was confirmed by a general election on December 13, 1905. His government was re-elected in 1908 and again in 1912.

With his background in federal politics and the newspaper business, Scott was well qualified to meet the many political and administrative challenges he faced in building the infrastructure for the new province. During his eleven years as premier (1905-16), Scott and his government confirmed Regina as the capital city, established the University of Saskatchewan, supported the formation of cooperative rural telephone and grain elevator companies, granted the vote to women, closed privately owned bars and established an independent system of selling alcohol, built roads throughout the province, and established a public service. But perhaps Scott's greatest legacy was the construction not only of the province's Legislative Building, but of an urban park that has grown to become the present-day Wascana Centre.

Sadly, Walter Scott was less successful in his personal life than in his public one. Afflicted with chronic depression, he eventually found the "burden of responsibility as legislator" too much to bear, and left office in 1916. His repeated efforts to cope with his depression were largely ineffective, and in 1938 he died, alone, in an Ontario psychiatric hospital.

Site Selection

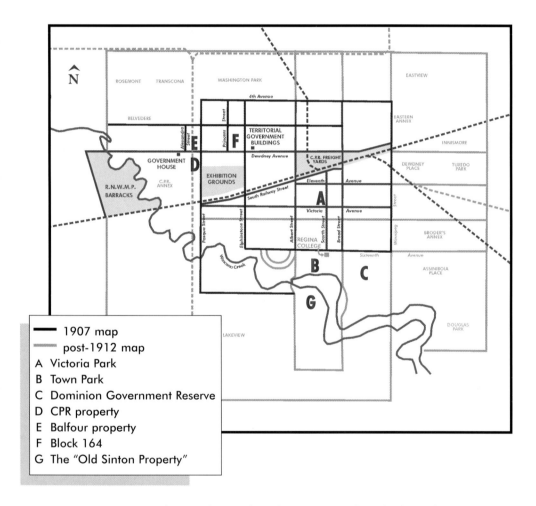

▬	1907 map
▬	post-1912 map
A	Victoria Park
B	Town Park
C	Dominion Government Reserve
D	CPR property
E	Balfour property
F	Block 164
G	The "Old Sinton Property"

SITES UNDER CONSIDERATION: This map of Regina shows the seven proposed sites for the Legislative Building. The solid black lines show the city as it was at the time the site was being selected; the grey portion of the map shows how the city developed during the Saskatchewan Legislative Building's construction period.

Less than a year after the new province was created, planning for Saskatchewan's new Legislative Building was already underway. The selection of a site for this new building was the first step in the process. In the early spring of 1906, the Honourable J.A. Calder, Minister of Education and Deputy Premier, was entrusted with the task of examining potential sites for the Legislative Building. On June 14, Calder made his report to Premier Scott, outlining seven proposed sites.

The first suggestion was Victoria Park, a parcel of six acres, which was seriously considered because of its proximity to the business centre of town. However, Walter Scott envisaged a building which would be large enough to meet not only the province's present but its future requirements as well. Scott was also committed to the creation of a large park around the government building for the enjoyment of the province's citizens. As such, it was concluded that the Victoria Park site was too small. The second suggested site, Town Park, north of the reservoir and bordered by Albert Street and College Avenue, was likewise thought to be too small.

The third option, the Dominion Government Reserve, was a property bounded by Broad and Winnipeg Streets and College Avenue. However, Calder believed that, since Regina was growing to the north and west, this site was too far from the centre of town and thus was not a choice location.

Calder also ruled out the fourth option, property held by the Canadian Pacific Railway which was located near the present-day exhibition grounds. Although the property was large enough, Calder felt that it was too close to the railway tracks, and hence was unsuitable.

Of the remaining three options, two properties were located on Dewdney Avenue, one near Government House, the Lieutenant Governor's

official residence, the other near the Territorial Government Buildings. Calder believed that these sites were possible alternatives, if acceptable to his cabinet colleagues.

The final option—and that recommended by Calder—was a parcel of land just south of the reservoir called the "Old Sinton Property." This 168-acre site was owned by the McCallum Hill Company and was listed at $108,000. In making his recommendation to Premier Scott, Calder described the site:

> It lies high and if the buildings were erected there, they would face the city and at the same time overlook the reservoir. The grounds could easily be beautified, prison labor being available for this purpose. Water and sewage connections could easily be made at a comparatively small cost. While at first I thought the property too far from the centre of the City, upon examination, I found it just as close as the Dewdney properties. Besides, in deciding the question of a site, the fact must be borne in mind that at an early date, there is every likelihood that we will have a street car service.

Scott and his government accepted Calder's recommendation and bought the property for $96,250, but the wisdom of this choice was questioned by many Regina citizens. For one thing, the site was isolated, with almost no other buildings located in the vicinity. Secondly, since the site was south of Wascana Creek, concern was expressed at the expense which would be involved in constructing a bridge linking the proposed Legislative Building to the rest of the city. Clearly, to many, a site closer to town was a more logical choice, and on July 3, 1906, the Regina City Council passed a resolution urging the government to locate the building north of the reservoir in the Town Park. Premier Scott politely declined the Council's proposal but did offer to incorporate the Town Park into the landscaping plans for the Legislative Building, an offer that the Council accepted.

JAMES ALEXANDER CALDER: Appointed by Premier Scott to evaluate the potential sites for the Legislative Building, Calder was a capable politician who had gained experience in the territorial government. He would eventually serve as acting premier on several occasions as Scott's health worsened over the years. In 1917, Calder would leave provincial politics and join Prime Minister Robert Borden's "Union Government" in Ottawa.

VICTORIA PARK, REGINA: Still treeless in this early photo looking south up Cornwall Street, Victoria Park (also called Victoria Square) was seriously considered as a potential site for the Legislative Building. In 1907, the city hired Montreal landscape architect Frederick Todd to develop plans for the park.

SAB R-B 3694

SAB E.B. WILLIAMS ALBUM p. 8

The Architectural Competition

SAB R-B 3681

F.J. (FRANKLIN JOSEPH) ROBINSON, DEPUTY MINISTER OF PUBLIC WORKS: The photograph above was taken in 1904 when Robinson was the Director of Surveys in the North-West Territorial Government. (Note the map on the wall behind Robinson showing the territorial districts.) This office was located in the old Regina Trading Company building on South Railway (now Saskatchewan Drive).

Having purchased the property for the province's Legislative Building, the Scott government hired Frederick Todd, a landscape architect from Montreal, to propose the actual building site and to begin plans for a park to surround the new building.

Once Todd had chosen where the building would be situated on the property, the next important decision was to pick an architectural plan. One of the key men in choosing the design and overseeing the construction of the building was F.J. Robinson, Deputy Minister of Public Works. He and Walter Scott (who, in addition to being premier was also minister of Public Works) worked closely together on their dream of building a masterpiece, a symbol of democracy and government that would suit the glorious future which they believed lay before the Province of Saskatchewan.

At first, Scott was inclined to choose an architect whom he knew and one who had some experience in the field. He had met Cass Gilbert, an architect in New York, whose abilities had been proven in his design of the new state capitol building in St. Paul, Minnesota. Scott was also acquainted with F.M. Rattenbury, an architect in Victoria, British Columbia, who had designed the widely acclaimed Legislative Building in that city.

However, this approach proved to be too personal for many, and when the media learned that Scott had visited Rattenbury, public pressure was exerted on the premier not to choose a friend as the architect but rather to have a public competition. Various architectural firms wrote to Scott seeking the contract for the Legislative Building. Finally, after further pressure from his cabinet

colleagues, Scott decided to have a limited competition where selected architects would be invited to submit drawings and designs. Scott wrote to Rattenbury to tell him the news of the competition:

> *While my personal view is pretty strongly in favor of putting the work directly in the hands of an architect if [sic] acknowledged standing, I found the competitive method, especially with regard to a public building, appealed to some of my colleagues with force. We have decided in favor of holding a competition.*

Scott and F.J. Robinson then invited Percy Nobbs, professor of Architecture at McGill University, to be their chief architectural advisor and head of the committee of assessors; other committee members included Bertram Goodhue of New York and Frank Miles Day of Philadelphia.

Nobbs and Robinson immediately began to prepare the specifications for the new building. The government decided that the building should cost between $750,000 and $1 million. Robinson's first priority was that the building would be fireproof, and suggested that the exterior be red brick (with sandstone trimmings). Also, given the extremes of a prairie climate, it was specified that the building must be designed to withstand a temperature variation of up to 140 degrees Fahrenheit.

In keeping with the Scott government's confidence in the future growth of Saskatchewan, it was decided that provisions be made for future expansion. As such, Robinson specified that the building be designed so that it could be easily enlarged by adding wings when necessary. It was also concluded that the Legislative Chamber must be large enough to accommodate 125 members of the Legislative Assembly (at a time when the Assembly was composed of only 25 members). As Robinson wrote, the building should be

> *designed with a view to provide a Legislative Chamber and the usual accommodation rooms large enough to satisfy the wants of the province for all time to come and to provide room for departmental offices sufficient to accommodate the departments, say double their present requirements.*

In addition to these recommendations, Scott noted that since the landscape surrounding Regina was extremely flat, and since the building would be some distance from the city centre, there should be a tower or a dome to ensure that the Legislative Building would be a true landmark.

With the assistance of Percy Nobbs, Scott invited seven architectural firms to compete for the design of the new Legislative Building: Edward and W.S. Maxwell of Montreal, F.M. Rattenbury of Victoria, Storey and Van Egmond of Regina, Darling and Pearson of Toronto, Marchand and Haskell of Montreal, Mitchell and Raine of London, England, and Cass Gilbert of New York. Scott was under great pressure from fellow Liberals to invite the firm of Sproatt and Rolph, the "best friends financially the Liberal Party have in Canada," but he refused, stating that the selection included one local firm, one American, one British, and four Canadian firms. Scott argued that this represented a good cross-section of the architectural profession, and he was confident that the end result would be worthy.

Scott was determined that the jurors make the selection based on good architectural standards, free of either personal or political pressure. To accomplish this, each architect, after receiving broad guidelines from the province, was invited to submit his plans to F.J. Robinson, who in turn numbered them, removed the architect's name, and sent the

CANADIAN ARCHITECTURE COLLECTION, McGILL UNIVERSITY

PERCY NOBBS (1875–1964)

WHAT MIGHT HAVE BEEN: Depicted on these two pages are the building designs of the unsuccessful competitors.

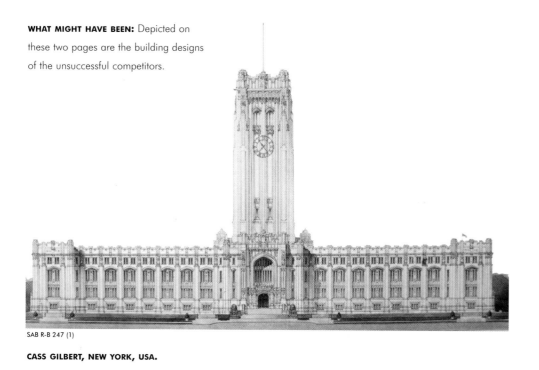

SAB R-B 247 (1)

CASS GILBERT, NEW YORK, USA.

submissions to the selection committee. On December 20, 1907, Nobbs wired Robinson to give him the numbered plan of their choice. The following day, Robinson advised the seven candidates that Edward and W.S. Maxwell of Montreal had been selected as the architects of the new building. Scott was not in Regina when Robinson received the jury's verdict.

Scott's determination not to influence the choice was a wise decision on his part, since it freed him from allegations of misusing his influence. Were any problems or complaints to arise concerning the choice of architects, these could be referred directly to Nobbs and his committee of assessors.

The general reaction to the Maxwell brothers' design—and to the way the competition had been held in general—was favorable.

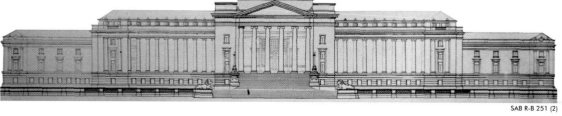

SAB R-B 251 (2)

F.M. RATTENBURY, VICTORIA, BRITISH COLUMBIA.

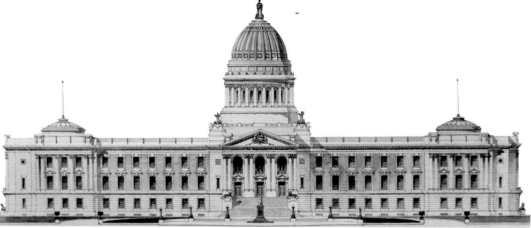

SAB R-B 252 (3)

STOREY AND VAN EGMOND, REGINA, SASKATCHEWAN.

The architectural firm of Darling and Pearson, one of the unsuccessful competitors, wrote: "We know of no competition that has been framed during recent years that has met such universal approbation among the profession."

By the close of the competition and the awarding of the general construction contract, the projected price for the building had risen to $1,750,000—one million dollars more than the original estimate. The government instructed the architects to avoid waste and extravagance, yet have the building "worthy" of the province. For every decision made on the project, the attitude of Robinson and Scott was that the structure was going to be built only once, so it had to be done correctly the first time.

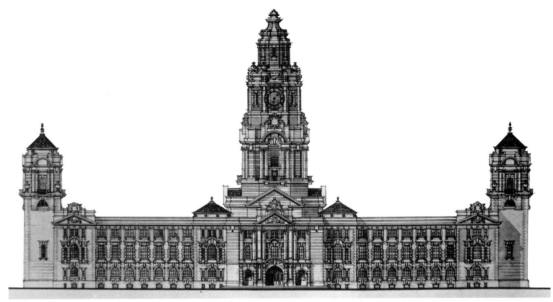

SAB R-B 250 (2)

MITCHELL AND RAINE, LONDON, ENGLAND.

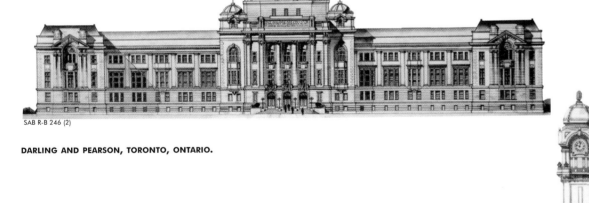

SAB R-B 246 (2)

DARLING AND PEARSON, TORONTO, ONTARIO.

MARCHAND AND HASKELL, MONTREAL, QUEBEC.

SAB R-B 248 (1)

13

The Maxwell Brothers' Winning Design

Edward and W.S. (William Sutherland) Maxwell were two Montreal architects at the height of their careers when they were awarded the contract to design and supervise the construction of the Saskatchewan Legislative Building. Edward had been educated in Montreal and Boston and opened a private practice in Montreal in 1892, where he was joined by his brother in 1902. W.S. Maxwell had also studied in Montreal and Boston, as well as at the École des Beaux Arts in Paris. Edward began his career by designing homes for wealthy families in Montreal, but the brothers soon branched out into designing commercial structures, churches, and civic and cultural buildings. Some of their more well-known designs include an addition to the Chateau Frontenac in Quebec City, and the Canadian Pacific Railway station in Winnipeg.

In designing the Saskatchewan Legislative Building, the Maxwell brothers took into account several key considerations: the British heritage in the Canadian system of government, the premier's request to include a dome so that the building could be seen for miles around, and the influence of an inclement climate with hot, dry summers and cold winters. However, they were determined that the building, while designed with

SAB R-B 249 (1)

these practical considerations in mind, be aesthetically pleasing as well.

The practicality of the architects' plans is apparent throughout the building. For example, in order to provide good working space with adequate lighting, the Maxwells opted for a rectangular design, with four wings, two long corridors, and a central meeting place at the intersection of the four wings. Each wing has abundant window space for lighting, with huge arched windows on the second floor and at the end of the east and west wings. The reading rooms and library were located on the north side of the building to avoid the sun's glare off the snow in winter. Practical use was made of the available space throughout the building, as can be seen by the unobtrusive but functional placement of elevators, washrooms, cloak rooms, staircases, and vaults for the storage of important documents. The Maxwells were able to include these utilitarian aspects while still offering a sense of spaciousness and grandeur.

The executive and legislative functions were given clearly defined space within the building. On the second floor, the north wing was devoted to suites for the premier, the lieutenant governor, and the cabinet (the executive arm of government). On the same floor, the south wing houses the Legislative Chamber. The east wing is home to the Legislative Library, as well as the office of the leader of the Opposition.

As specified in the guidelines for the design competition, the Maxwells' architectural design for the Legislative Building also included provisions for future expansion. The southern sides of the ends of the east and west wings were designed so that two new wings could be added if needed, without destroying the original design. The two new wings would stretch south beyond the power plant and then come together to enclose the plant in a courtyard.

SAB R-A 2443

SAB R-B 967

W.S. MAXWELL (1874–1952), LEFT; EDWARD MAXWELL (1867–1923), BELOW:

The Maxwell brothers felt that the exterior of the building was representative of British sovereignty and believed that the building was "all that could be desired to house the Legislature and administration of what is destined to be one of the most important provinces of the Dominion."

To date, this expansion has not been undertaken. While new buildings have been built over the years on the legislative grounds to house expanding government services, the Legislative Building itself is still the same size and shape as originally designed.

Practical, functional, yet pleasing to the eye, the Maxwell brothers' design truly succeeded in creating an edifice that has stood the test of time. A monument to the British parliamentary tradition, the Saskatchewan Legislative Building is nevertheless supremely well suited to its role as the centre of a modern, forward-looking society. Could they see the results of their labours today, the Maxwell brothers would be rightly proud.

Legislative Building Facts

- Three thousand and fifty-one piles were used under the building's foundation; 40 percent of these are situated under the dome.
- From ground level to the top of the dome, the building is 56 metres (approximately 183 feet) high.
- End to end, the building is 167 metres (about 542 feet) long.
- From the North to the South Wings, the building is 94 metres (approximately 308 feet) wide.
- There are more than 300 rooms in the building.
- The building's street address is 2405 Legislative Drive.

- After nearly a century of inflation, you might not build it today! When the building was opened in 1912, it had cost about $1.75 million—more than double the original estimate. In 1979, the television system installed to broadcast sessions of the Legislative Assembly cost almost as much—$1.5 million. The four-year building restoration project completed in 2001 cost $18.6 million, more than ten times the 1912 price for the whole building, and the current replacement value is estimated at $190 million—after nearly one hundred years, more than one hundred times the original cost of construction!

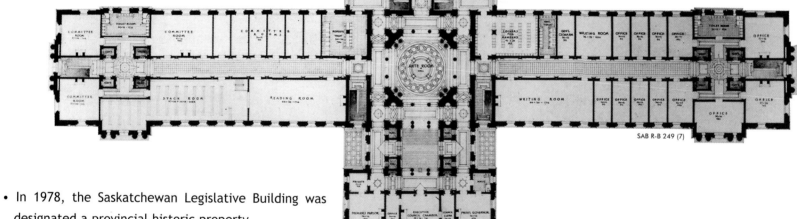

SAB R-B 249 (7)

- In 1978, the Saskatchewan Legislative Building was designated a provincial historic property.
- Originally situated on a 168-acre site, the Legislative Building today is the focus of Wascana Centre (one of the largest urban parks in the world), encompassing 2,300 acres (2,000 acres of land, and 300 acres of water). By comparison, New York City's Central Park is 834 acres.
- One of Saskatchewan's most popular tourist destinations, the Legislative Building has more than 50,000 visitors each year.

THE ARCHITECTS' PLANS hint at the grandeur and dignity of the building-to-be. The main floor plan (above) is evidence of the beauty of symmetry; the 1/4" scale detail drawing (facing page) reveals the complex planning which underlies the stately pillars and generous staircase of the main entrance.

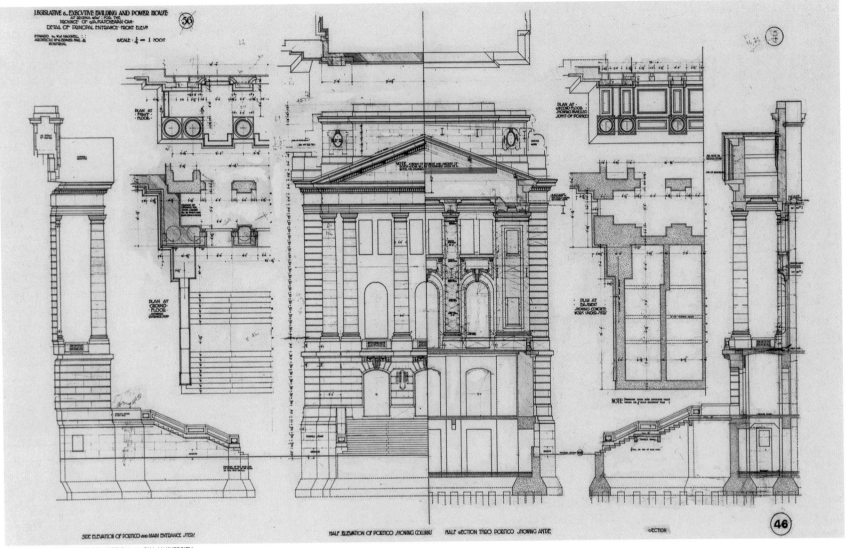

CANADIAN ARCHITECTURE COLLECTION, McGILL UNIVERSITY

Other Canadian buildings designed by the Maxwells

• S.R. Ross Office Building, Saskatoon, Saskatchewan, 1912 (demolished) • Church of the Messiah, Montreal, Quebec, 1907 (destroyed by fire) • Bell Telephone of Canada Company Building, Winnipeg, Manitoba, 1896 • Montreal Stock Exchange, Montreal, Quebec, 1904 • *for the Canadian Pacific Railway:* • Palliser Hotel, Calgary, Alberta, 1914 • Train Station, New Westminster, British Columbia, 1899 • Royal Alexandra Hotel and Train Station, Winnipeg, Manitoba, 1906 • Train Station and Hotel, Moose Jaw, Saskatchewan, 1898 •

Laying the Groundwork

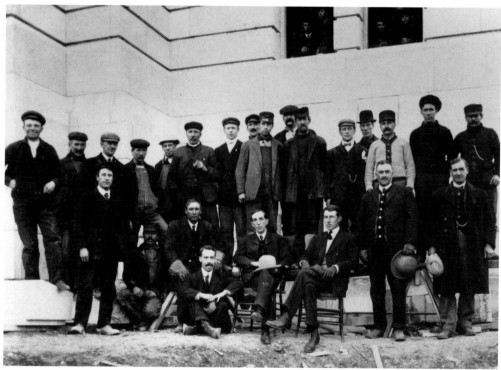

SAB LECKY ALBUM NO. 2 NO. 31A

STAFF OF P. LYALL AND SONS: P. Lyall and Sons was the Montreal contractor chosen to construct the Legislative Building. Over the first two decades of the twentieth century, the firm established itself as one of the country's leading construction companies. In 1914, the company again worked with the Maxwell brothers building the Canadian Pacific Railway's Palliser Hotel in Calgary, Alberta. In 1916, P. Lyall and Sons was responsible for the reconstruction of the Parliament Buildings in Ottawa after fire destroyed much of the original structure on February 4 of that year.

Once the architects had been chosen and the plans completed, the next task for the Scott government was to choose a general contractor. The Maxwell brothers expressed great concern on this topic. It was very important that the contractor be large enough to remain financially viable throughout the construction phase, and for this reason the Maxwells recommended that the contractor be from eastern Canada. Premier Scott, on the other hand, favoured local contractors.

The advertisements for tenders went out on May 23, 1908, and by July a contract was signed with P. Lyall and Sons of Montreal. Theirs was not the lowest tender, but the Maxwells and the government believed that the Lyall firm was the most financially able to complete the contract. There were charges of collusion over prices between the contractors and the architects, since they were both from Montreal, but an investigation by the government failed to find any evidence of price-fixing. Scott's determination to avoid controversy was apparent throughout the construction phase, and there is no evidence of blatant patronage in the hiring of construction workers, who were required to supply letters of reference and proof of competence.

The Maxwell brothers were aware of the pressure to hire locally but insisted on quality craftsmanship. Local suppliers and workmen were used when possible, but the province brought in outside expertise and materials in order to maintain a high standard of workmanship. The fact that most of the labourers were local men led, in fact, to an unusual, and unforeseen, problem in the fall of 1909. The contractor was pushing to close in the building before winter, but work stopped because the labourers left the job site to participate in harvest. Fortunately, construction continued after the end of harvest, and the west wing was enclosed before winter, thus allowing the interior work to continue.

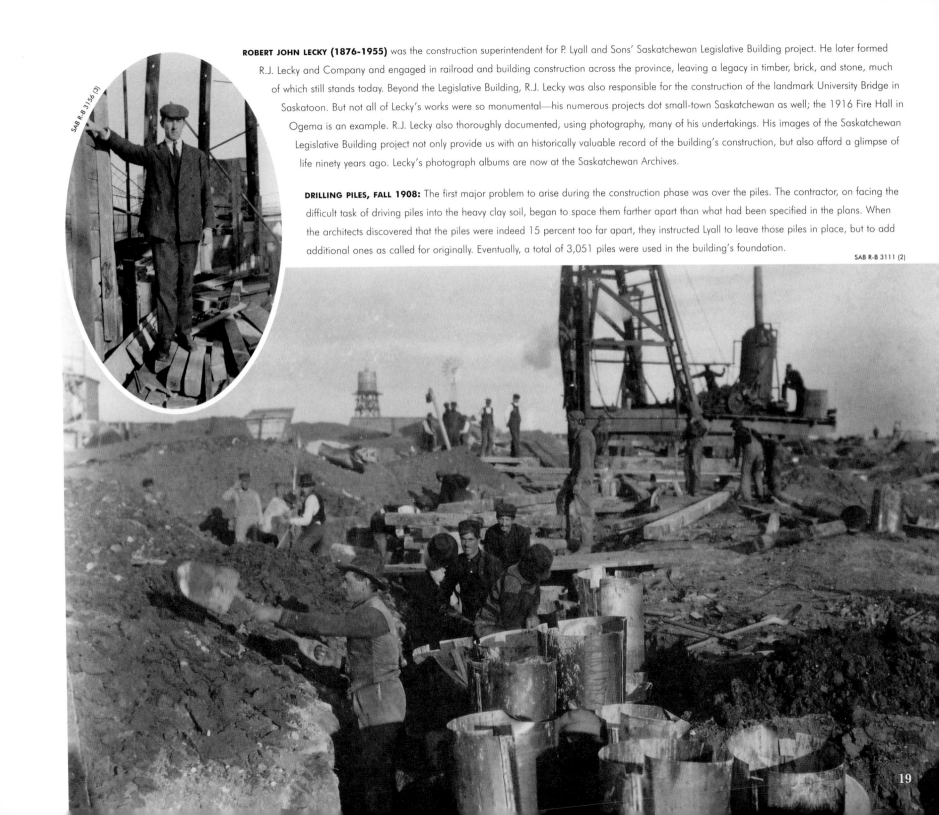

SAB R-B 3156 (3)

ROBERT JOHN LECKY (1876-1955) was the construction superintendent for P. Lyall and Sons' Saskatchewan Legislative Building project. He later formed R.J. Lecky and Company and engaged in railroad and building construction across the province, leaving a legacy in timber, brick, and stone, much of which still stands today. Beyond the Legislative Building, R.J. Lecky was also responsible for the construction of the landmark University Bridge in Saskatoon. But not all of Lecky's works were so monumental—his numerous projects dot small-town Saskatchewan as well; the 1916 Fire Hall in Ogema is an example. R.J. Lecky also thoroughly documented, using photography, many of his undertakings. His images of the Saskatchewan Legislative Building project not only provide us with an historically valuable record of the building's construction, but also afford a glimpse of life ninety years ago. Lecky's photograph albums are now at the Saskatchewan Archives.

DRILLING PILES, FALL 1908: The first major problem to arise during the construction phase was over the piles. The contractor, on facing the difficult task of driving piles into the heavy clay soil, began to space them farther apart than what had been specified in the plans. When the architects discovered that the piles were indeed 15 percent too far apart, they instructed Lyall to leave those piles in place, but to add additional ones as called for originally. Eventually, a total of 3,051 piles were used in the building's foundation.

SAB R-B 3111 (2)

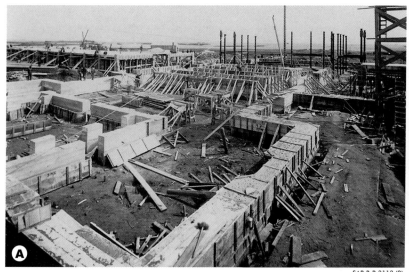

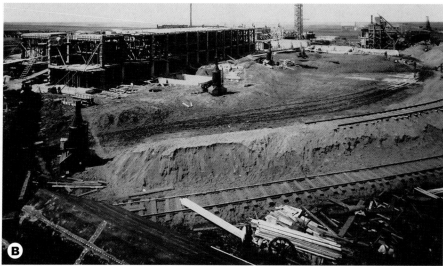

SAB R-B 3113 (2)

SAB R-B 3116 (1)

EARLY CONSTRUCTION: A. Foundations, May 5, 1909. **B.** View from northeast, June 1, 1909. **C.** View from south of the building, July 23, 1909—a year after construction began. **D.** Contractors P. Lyall and Sons conduct a test of a reinforced concrete beam. Forty tons of sandbags were used to test the beam's displacement. **E.** Beginnings of the Grand Staircase and the North Wing, July 23, 1909—again, one year from the start date. **F.** View from the northeast, August 4, 1909.

During the concrete-pouring phase, between 120 and 212 men laboured on site daily. Construction stopped during the winter of 1908–09 but many of the supplies needed in the spring were stockpiled. The construction process was halted on a number of occasions because of labour disputes. The wages of the junior carpenters were 17.5¢ per hour but, after a short work stoppage in the spring of 1909, were increased to 20¢ per hour. Then, in January 1910, the bricklayers went on strike over wages and the use of unskilled workers. The strike ended when Lyall agreed to use only qualified bricklayers. In May 1910, the carpenters and electricians went on strike. Their work stoppage lasted approximately six weeks before a settlement was finally reached.

SAB R-B 3122 (1)

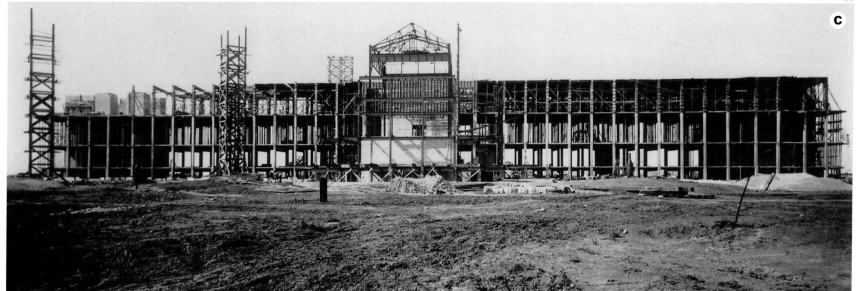

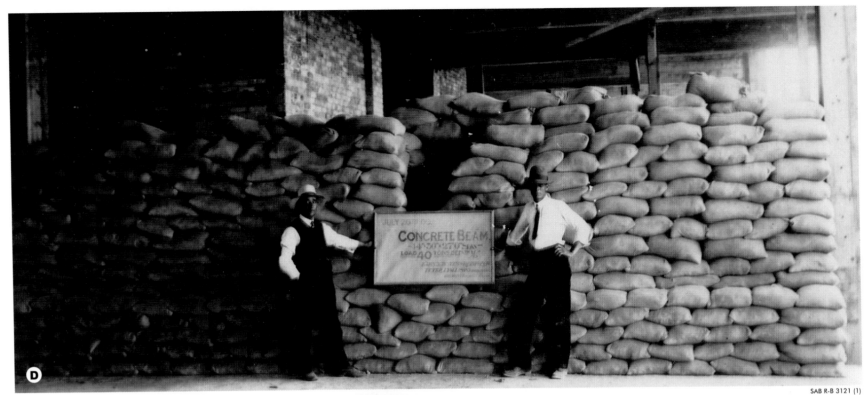

SAB R-B 3121 (1)

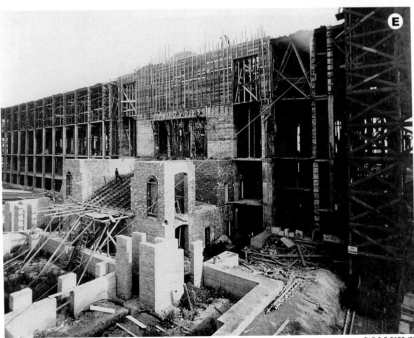

SAB R-B 3122 (2)

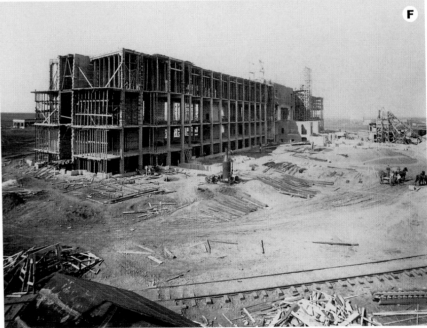

SAB R-B 3123 (2)

21

From Red Brick to Tyndall Stone

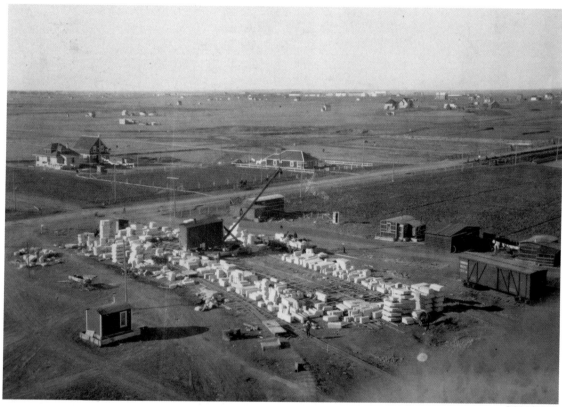

SAB R-B 3157 (2)

THE TYNDALL STONE arrived by rail and was piled up at the site. This view from the roof of the building looks northwest. The Albert Street dam across Wascana Creek can be seen on the right—the original wooden dam constructed in 1882 was located further to the west, around Rae Street.

One of the most outstanding features of the present Legislative Building is its exterior Tyndall stone. The stone has stood the test of time and gives the building a note of quiet grandeur. But the present building's exterior is not what was specified in the plans—red brick was the original choice of the government and the architects. It was not until the spring of 1909, when many of the red bricks were already on-site, that Walter Scott began to explore the idea of using Tyndall stone. After consultation with F.J. Robinson and the Maxwell brothers, Scott decided to proceed with Tyndall stone at an additional cost of some $50,000.

The stone could be obtained from Tyndall, Manitoba, but since a new quarry had to be opened and a rail line built to the site, some delays were experienced. Nevertheless, despite the delays and the additional costs, Scott's decision to use Tyndall stone was an inspired one. We need only try to visualize the Legislative Building with a red-brick exterior to realize that, although the decision was made in midstream, it was well worthwhile insofar as the building's esthetic quality was concerned.

The decision to use Tyndall stone was not the only change made to the plans after construction had started. The marble pillars in the main rotunda and the oak panelling in the Legislative Chamber were also additions to the original contract. In fact, by the time the building was completed, ninety-one additional agreements for design changes had been made with the architects.

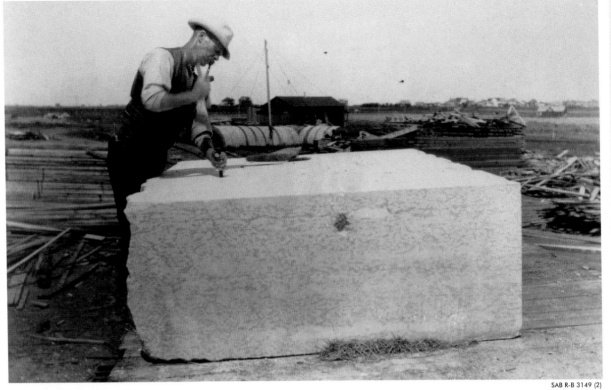

SAB R-B 3149 (2)

JULY 1910: Above, a stonemason works on an eight-ton block of stone for the East Wing.

TRACES OF THE PAST: This receptaculite fossil (left) is commonly referred to as Sunflower Coral. Once classified as a sponge, this extinct group is now believed to have been a form of red algae—not related to coral at all! The nautiloid fossil (below) is a cone-shaped ancient sea dweller which has living coiled descendents belonging to the modern genus *Nautilus*.

DAVID McLENNAN

DAVID McLENNAN

Tyndall stone is a mottled fossiliferous dolomitic limestone quarried from Garson, Manitoba, 37 kilometres northeast of Winnipeg—its name was acquired from Tyndall, the closest railway point. The Garson quarry was opened in 1895; however, the first record of the stone being used for construction purposes extends back to 1832 when it was used to build the walls and warehouse of Lower Fort Garry.

Today, Tyndall stone, sometimes referred to as "tapestry stone," adorns some of the finest buildings in North America. It is used for exteriors, interiors, steps, columns, fireplaces, and floors. Significant projects using this beautiful and distinctive rock include the Parliament Buildings in Ottawa, the Manitoba Provincial Legislative Building, the Canadian Museum of Civilization in Hull, the Empress Hotel in Victoria, the Lied Center for the Performing Arts in Omaha, and the Walsh Center for the Performing Arts at the Texas Christian University campus in Fort Worth.

The diversity of fossil organisms found in Tyndall stone, along with paleomagnetic information, indicate that 450 million years ago Manitoba was a warm inland sea just south of the Ordovician paleoequator. Commonly observed fossils are trilobites, brachiopods, nautiloids, corals, and snails.

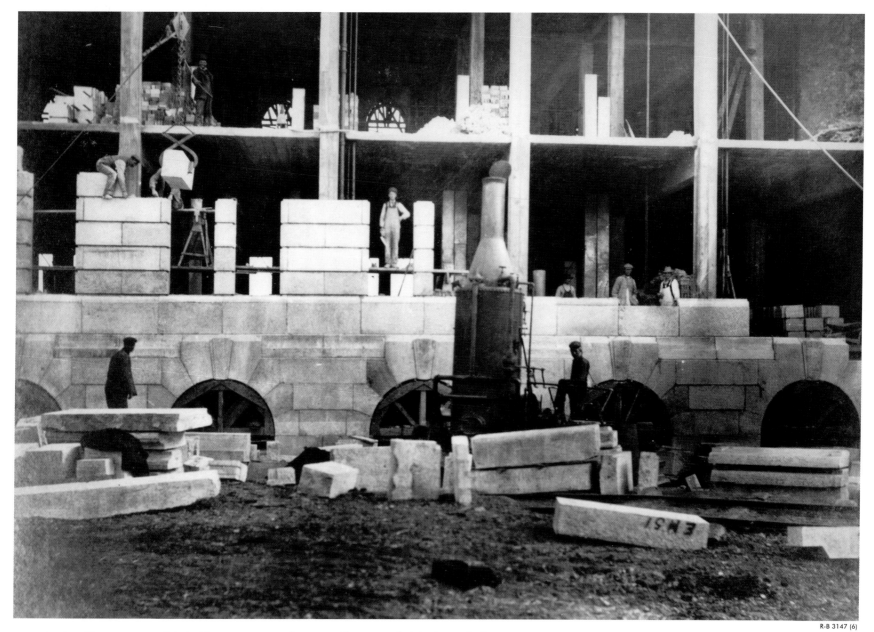

R-B 3147 (6)

JUNE 10, 1910: The construction of the building was innovative for its time. The outer walls helped carry the floor loads, and employing a new technique called the "Khan System," the structure was reinforced with trussed steel bars. The Assembly Chamber was built with steel and fireproofed using concrete. When finished, Saskatchewan's Legislative Building became the largest reinforced concrete building in Western Canada, establishing a landmark for Canadian architects in an era when most prestigious commissions went to non-Canadians.

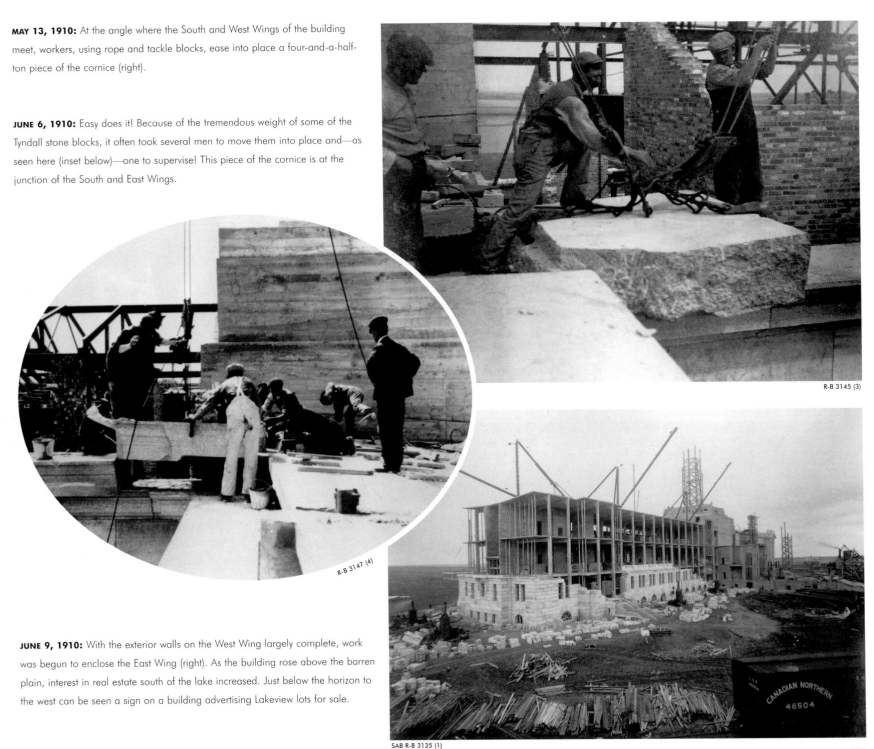

MAY 13, 1910: At the angle where the South and West Wings of the building meet, workers, using rope and tackle blocks, ease into place a four-and-a-half-ton piece of the cornice (right).

JUNE 6, 1910: Easy does it! Because of the tremendous weight of some of the Tyndall stone blocks, it often took several men to move them into place and—as seen here (inset below)—one to supervise! This piece of the cornice is at the junction of the South and East Wings.

R-B 3145 (3)

R-B 3147 (4)

JUNE 9, 1910: With the exterior walls on the West Wing largely complete, work was begun to enclose the East Wing (right). As the building rose above the barren plain, interest in real estate south of the lake increased. Just below the horizon to the west can be seen a sign on a building advertising Lakeview lots for sale.

CANADIAN NORTHERN
46504

SAB R-B 3135 (1)

The Cornerstone Ceremony

With the construction of the Legislative Building well underway, F.J. Robinson assumed further duties in the planning of one of Saskatchewan's first official ceremonies—the laying of the cornerstone. October 4, 1909, was chosen as the official date for the ceremony.

Robinson arranged for the purchase of 10,000 yards of red, white and blue bunting and 2,000 miniature flags. The bunting and flags were strung throughout the streets of the city, on the shell of the new building, and on the temporary grandstand that had been built for the occasion.

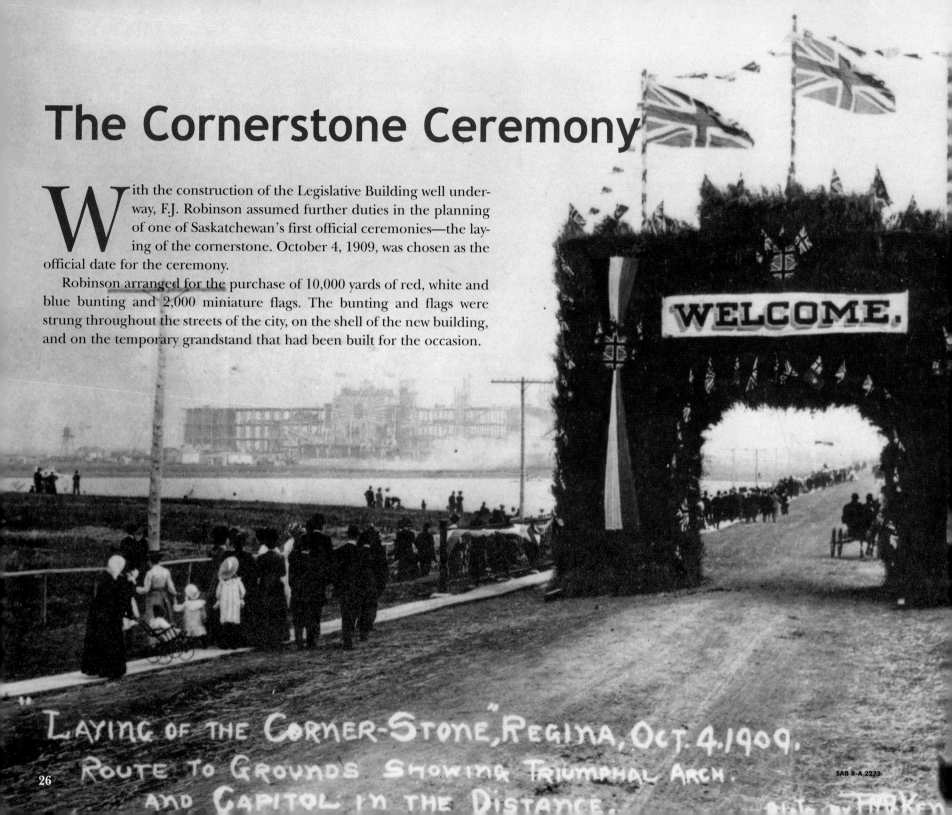

WELCOME.

LAYING OF THE CORNER-STONE, REGINA, OCT. 4. 1909.
ROUTE TO GROUNDS SHOWING TRIUMPHAL ARCH.
AND CAPITOL IN THE DISTANCE.

SAB R-A 2273

Robinson encountered an unforeseen problem when preparing the ceremonial trowel which is customarily used on such occasions. He had planned to use a buffalo horn as the trowel's handle, but since buffalo were by now almost extinct, he had difficulty in finding the necessary material. Fortunately, he was finally able to obtain a horn, which was mounted on the silver trowel used by the Governor General for the ceremony.

The traditional "time capsule" box for placement inside the cornerstone was also prepared. In it Robinson placed a Bible, a Union Jack, a photo of the Second Legislative Assembly, a copy of the plans for the building and a list of the people who had been involved in the construction, stamps, currency, a provincial telephone directory, and copies of various newspapers.

On October 4, Governor General Earl Grey and his entourage rode by carriage from Government House to the site of the Legislative Building. They were greeted by a royal salute from the Royal North-West Mounted Police and songs from a school choir. Spencer Page, the Clerk of the Legislative Assembly, led in prayer. The "time capsule" was deposited, and the Governor General then officially laid the cornerstone. Governor General Grey and Walter Scott spoke to the assembled crowd before leading an inspection of the honour guard and the new building.

The laying of the cornerstone was a remarkable public event. People from Regina and surround-

ing districts came to witness one of the most important ceremonies of the new province. Scott's words to those assembled demonstrated yet again his remarkable vision for the province:

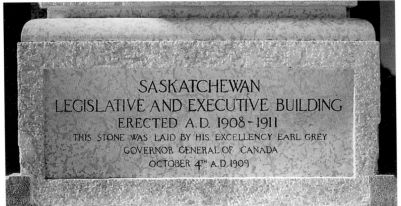

DAVID McLENNAN

I may say with pardonable pride that examination of the plans and design shows that, while it may be by no means huge or extravagant, it will be in appearance, stability and durability, such a building as any person may be willing without any hesitation to have his name associated with and inscribed upon—such a building as will appropriately represent the character and ambitions of the people of the province. …

We should build not merely for the population of today but to the population of the future, and that the population of the not too distant future of Saskatchewan demands a building of no mean dimensions.

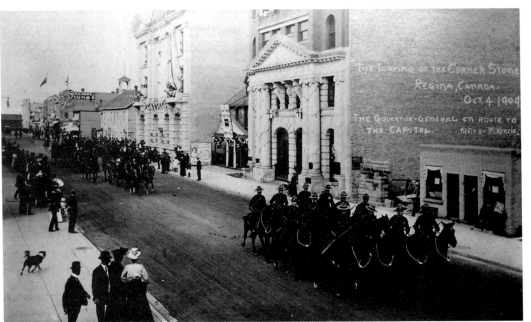

SAB R-A 7701 (1)

GOVERNOR GENERAL EARL GREY and his party were escorted by the Royal North-West Mounted Police (right) through downtown Regina en route to the construction site to lay the cornerstone (inset above) for the new Legislative Building.

27

SAB R-A 2272

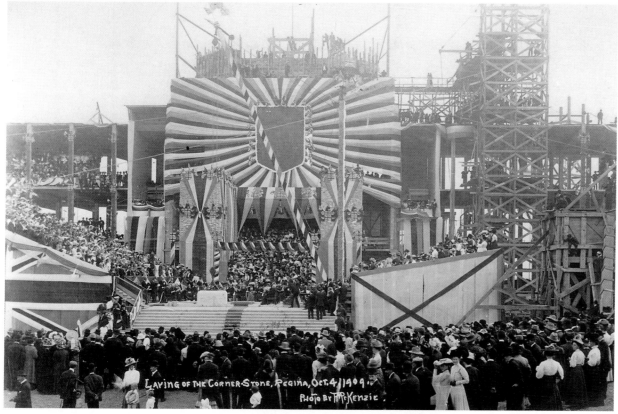

LAYING OF THE CORNER-STONE, REGINA, OCT. 4/1909.
PHOTO BY MCKENZIE.

GRAND STAND: The partially constructed building was elaborately decorated for the occasion with thousands of yards of bunting (left). The official participants in the cornerstone ceremony ascended a specially built ramp and then climbed seven steps (below left) in order to reach the stage of the temporary grandstand erected at the front of the building. The cornerstone (at far right in the photo) occupied "centre stage" during the ceremony.

THE KEY PART of the ceremony involved setting the cornerstone into position (below right).

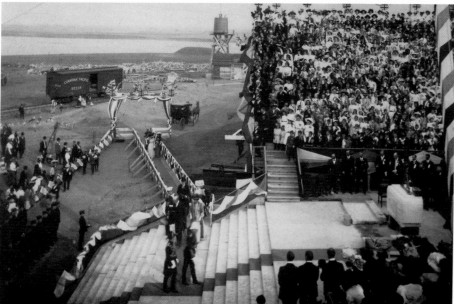

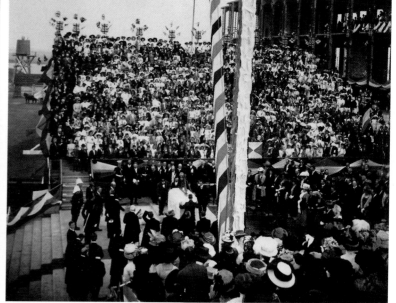

SAB R-B 3126 (2)

SAB R-B 1148 (1)

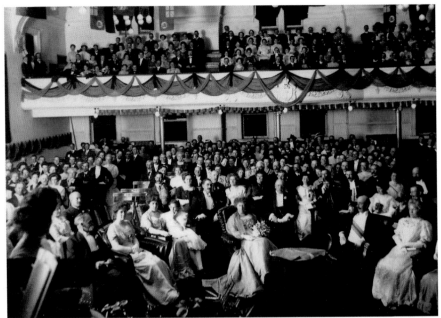

SAB R-B 3159

CROWDS GATHERED at City Hall (left) to welcome the Governor General and his entourage back from the ceremony at the Legislative Building. Opened in 1906, this City Hall served Regina until 1962 when it was vacated and the municipal government moved into the old Post Office. In 1965, the building was demolished to make way for a shopping mall.

EVENING RECEPTION: Honoured guests and the public gathered for an evening reception at City Hall (above). Seated in the foreground from left to right are: Mayor W.J. Smith and his wife, Mrs. Walter Scott and daughter Dorothy, Premier Scott, Lady Grey, Chief Justice Wetmore, Inspector Allard, RNWMP, Aide-de-camp, Earl Grey, Madame Forget, Comr. A.B. Perry, RNWMP, and his two daughters, Jessie and Gladys, Canon and Mrs. Hill of St. Paul's Church, Miss Mattie Martin, Mrs. W.M. Graham, Judge Rimner, and Miss Isobel Willoughby.

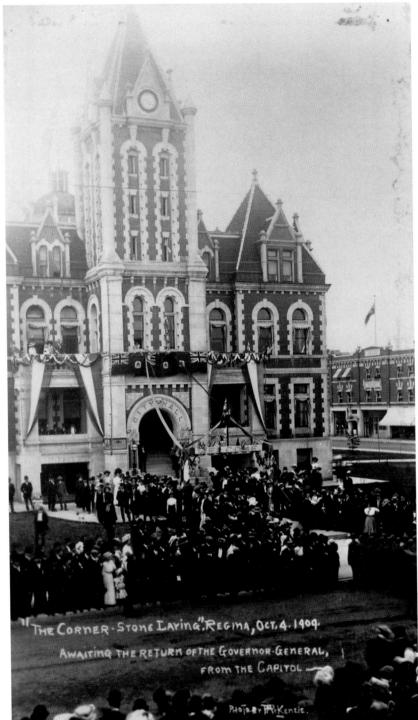

"THE CORNER-STONE LAYING", REGINA, OCT. 4, 1909

AWAITING THE RETURN OF THE GOVERNOR-GENERAL, FROM THE CAPITOL

PHOTO BY H. Kentie.

SAB R-A 23389 (2)

Construction continues...

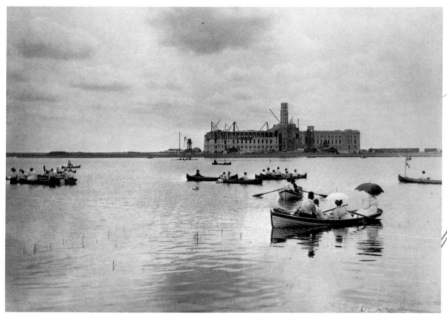

SAB R-B 9442

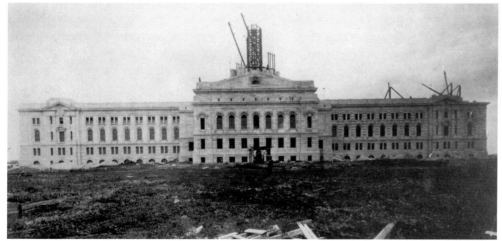

SAB R-B 3139 (1)

SAB R-B 3146 (4)

30

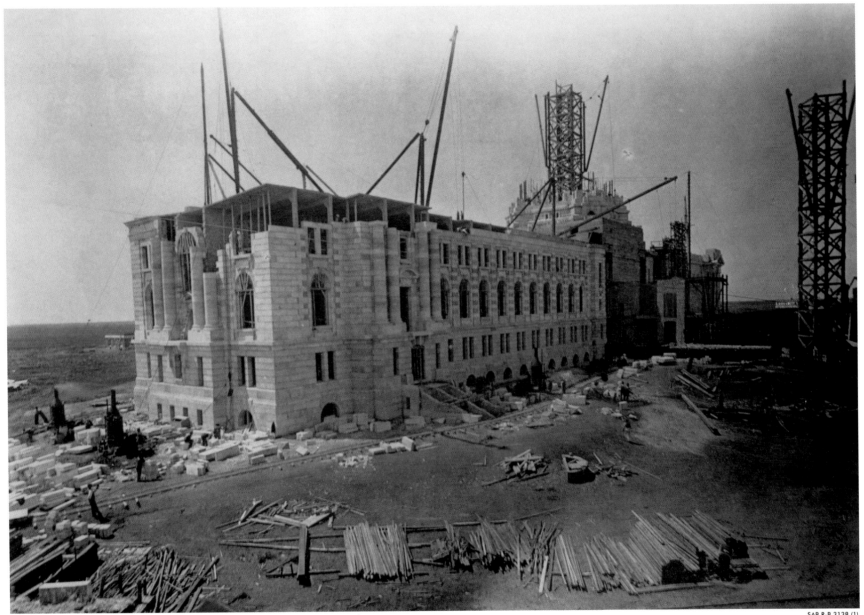

SAB R-B 3138 (1)

CURIOUS CITIZENS could while away a sunny day watching the progress on the Legislative Building (facing page, top left). Huge blocks of stone were being lifted into place on the outer walls, railcars moved back and forth on the track that had been laid to bring the building materials to the site, and workers scampered busily back and forth between the numerous outbuildings.

MASONS SET STONES on the upper reaches of the east face of the South Wing, May 21, 1910 (facing page, far right).

THE EAST WING was nearly enclosed by July 12, 1910 (above).

THE BUILDING as seen from the south on July 23, 1910—approximately two years after construction began (facing page, bottom left).

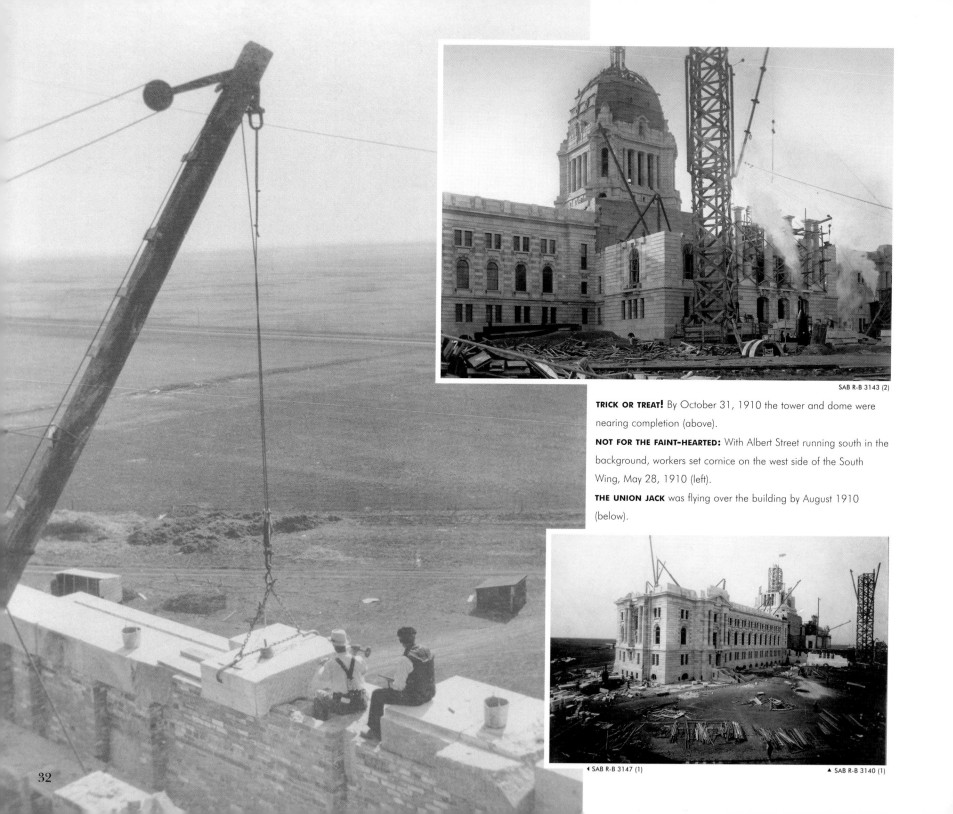

SAB R-B 3143 (2)

TRICK OR TREAT! By October 31, 1910 the tower and dome were nearing completion (above).

NOT FOR THE FAINT-HEARTED: With Albert Street running south in the background, workers set cornice on the west side of the South Wing, May 28, 1910 (left).

THE UNION JACK was flying over the building by August 1910 (below).

◄ SAB R-B 3147 (1) ▲ SAB R-B 3140 (1)

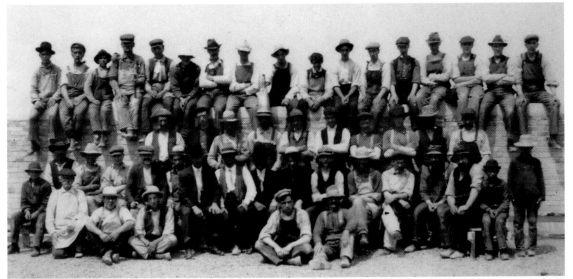

SAB R-B 3149 (1)

THE CARPENTER'S "GANG": This determined-looking group of men (above) was photographed July 10, 1910, about the half-way point of construction.

DRESS CODES were obviously different on construction sites ninety years ago. This dapper worker (below left) was using a hand drill to install fittings in a West Wing lavatory, August 30, 1910. Equally well dressed were three men (below right) installing terrazzo paving (a flooring material of stone chips set in concrete and polished to a smooth surface).

Occupational Hazard

On November 23, 1910, some government departments began to move into the West Wing of the building. Working in a building that was still under construction posed a number of problems. The deputy minister of Education complained in a letter to the deputy minister of Public Works that his employees could not work evenings because the electrical lights had not been installed. On one occasion, a piece of wood fell from the top of the rotunda, striking an accountant with the Department of Health and breaking his pocket watch. The province reimbursed him for the watch repairs.

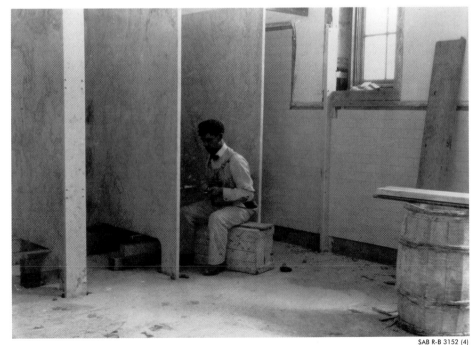

SAB R-B 3152 (4) SAB R-B 3152 (3)

Sentinel on the Prairie: The Dome

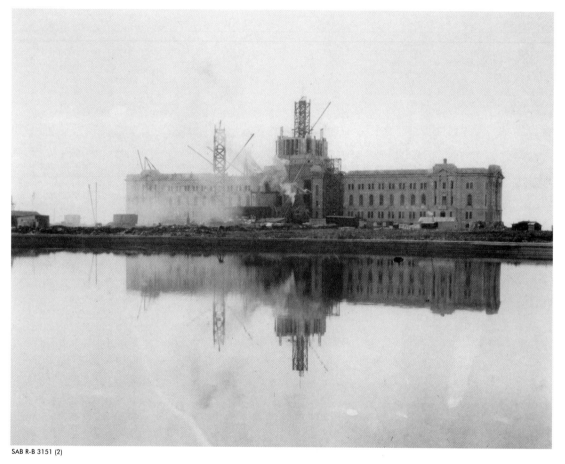

SAB R-B 3151 (2)

MONUMENTAL IN ITS ISOLATION, the Legislative Building had transformed the skyline south of the city by August 1910.

Its magnificent dome, which can be seen for miles, is perhaps the single most recognizable feature of Saskatchewan's Legislative Building, and the plans for its design were frequent topics of discussion between Scott and the Maxwells. At one point, it was planned to string 1,300 bulbs, at a cost of $8,800, over the dome to highlight its silhouette. The second option was to illuminate the front of the building and dome with searchlights at a cost of $5,500. Scott opted for the latter because he felt that the strings of lights would be too hard to maintain.

It was decided to have the top of the dome designed as a lantern. F.J. Robinson, the deputy minister of Public Works, suggested that the lantern should face north toward the town, with a red light when the Legislature was sitting and a white one when it was not. Walter Scott decided that the lantern should be four-sided so that it could be seen from all directions. He was certain that the town of Regina would soon grow out beyond the Legislative Building and felt that future generations should have the benefit of seeing the light atop the dome, no matter in which direction they lived. A white light was ultimately installed in the lantern and, to this day, it is illuminated each evening that the Legislative Assembly sits.

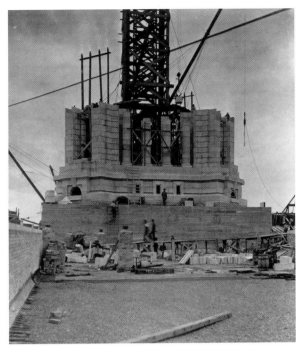

SAB R-B 3139 (2)

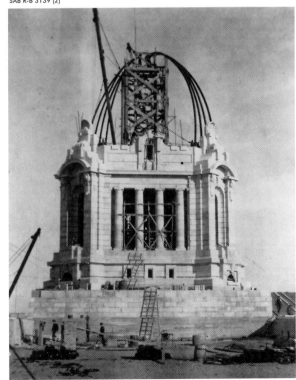

SAB R-B 3153 (1)

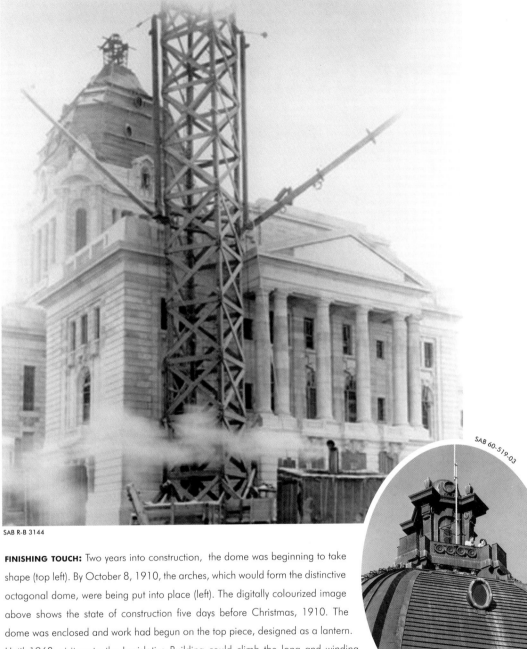

SAB R-B 3144

SAB 60-519-03

FINISHING TOUCH: Two years into construction, the dome was beginning to take shape (top left). By October 8, 1910, the arches, which would form the distinctive octagonal dome, were being put into place (left). The digitally colourized image above shows the state of construction five days before Christmas, 1910. The dome was enclosed and work had begun on the top piece, designed as a lantern. Until 1968, visitors to the Legislative Building could climb the long and winding staircase to the top of the dome for a view of the city and the surrounding countryside (inset, right). Since then, access to the area has been closed over concerns for public safety.

Exterior Details

In designing the exterior of the building a free adoption of English Renaissance work has been employed, as being best suited to the requirements, and offering a logical, sensible and architecturally interesting solution of the problem that marks it unmistakably as representative of the British sovereignty, under which the province is governed.... By careful study of massing, fenestration, outline and detail, a building such as is herewith presented should prove to be all that could be desired to house the legislature and administration of what is destined to be one of the most important provinces of the Dominon. To this end, dignity, simplicity and purity of style have been combined with a monumental treatment of the best period of British architecture, to produce a building that it is believed will serve its purpose in the best possible manner.

—from the Architects' Report

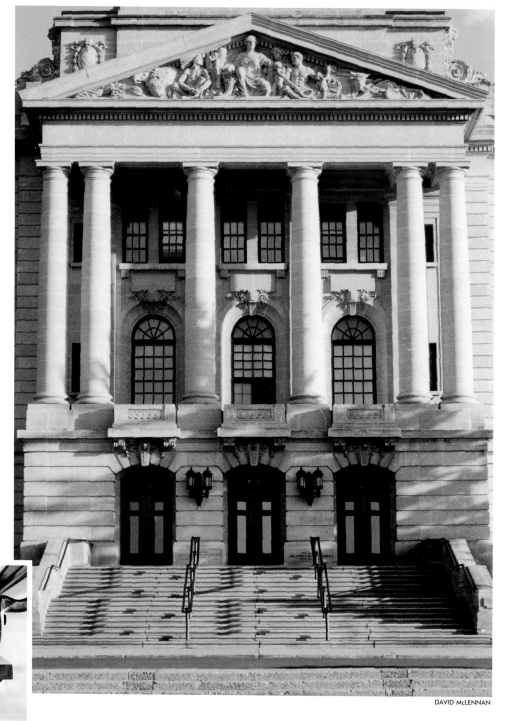

THE STYLIZED WHEAT SHEAF became an official provincial emblem in 1977. A variation of the sheaves on the provincial shield of arms, this now-familiar symbol has been set into the railings on the stairs at the main entrance to the building—a small yet significant detail, easily missed.

DAVID McLENNAN

DAVID McLENNAN

SAB 83-3057-R3-5

SYMBOLS IN STONE: The building is elaborately decorated with intricate carvings. Lions, gargoyles, and chains of interwoven grains and fruit adorn the exterior. As the building was completed during the reign of George V, many carvings also bear the inscription of GR for *Georgius Rex* (photos this page).

SAB 83-3057-R3-6

"UNBOUNDED OPTIMISM AND ENTHUSIASM": These words describe the sentiments which prevailed in western Canada in the early twentieth century, according to a letter sent from the Bromsgrove Guild of Montreal to the architects who designed Saskatchewan's Legislative Building. With the above sentiments in mind, the Guild designed and sculpted one of the most striking features of the exterior of the building—the stone pediment above the main doors (shown in facing photo)—at a cost of $1,500. In the centre of the stone carving is a woman, with a new Canadian settler and his family to her left and an Aboriginal family to her right. The woman in the pediment personifies Canada, and she is "inspiring the settler with all the glorious opportunities of agriculture in a magnificent province." The settler, with his cattle and grain, represented "the new developments toward the great future, which are rapidly taking place all over the province." On the other side of the pediment, the Aboriginal family expresses, in the words of the Guild, a feeling of "dignity … possibly sometimes even expressing doubts of the virtues of all the white-man's innovations…." The pediment was to express the strong yet subtle hope of new settlers and original inhabitants living and working together, with the message "that this Parliament is the building in which the laws of the province will be enacted for the benefit of all and not for the individual."

DAVID McLENNAN

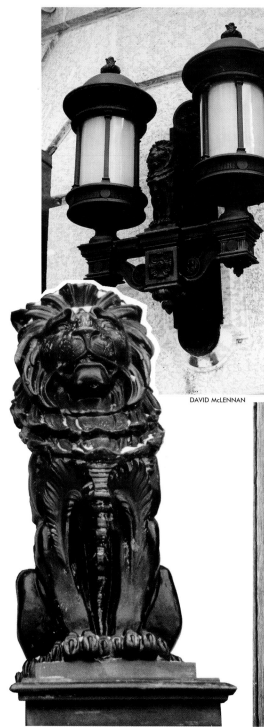

DAVID McLENNAN

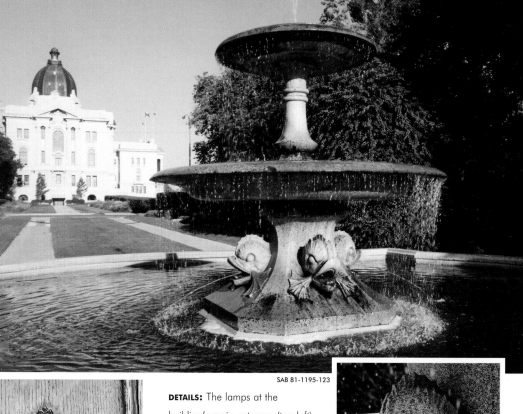

SAB 81-1195-123

DAVID McLENNAN

DETAILS: The lamps at the building's main entrance (top left) are beautiful as well as functional. Each has a lion at its centre—a silent sentry watching the building's comings and goings (lower left). For additional security, however, the building does indeed have locks—and these, too, are exquisitely crafted (left).

Augmenting the vista of the building's East Wing is the Trafalgar Fountain (above, detail right). Dominating the formal walkway leading from the shores of Wascana Lake, the fountain is one of a pair that stood in Trafalgar Square in London, England, from 1845 to 1939. Constructed of red granite from Scotland, the Trafalgar Fountain was dedicated in 1963 to the founding of the headquarters of the North-West Mounted Police in Regina in 1882. The companion fountain is now in Ottawa.

SAB 83-3057-R3-4

DAVID McLENNAN

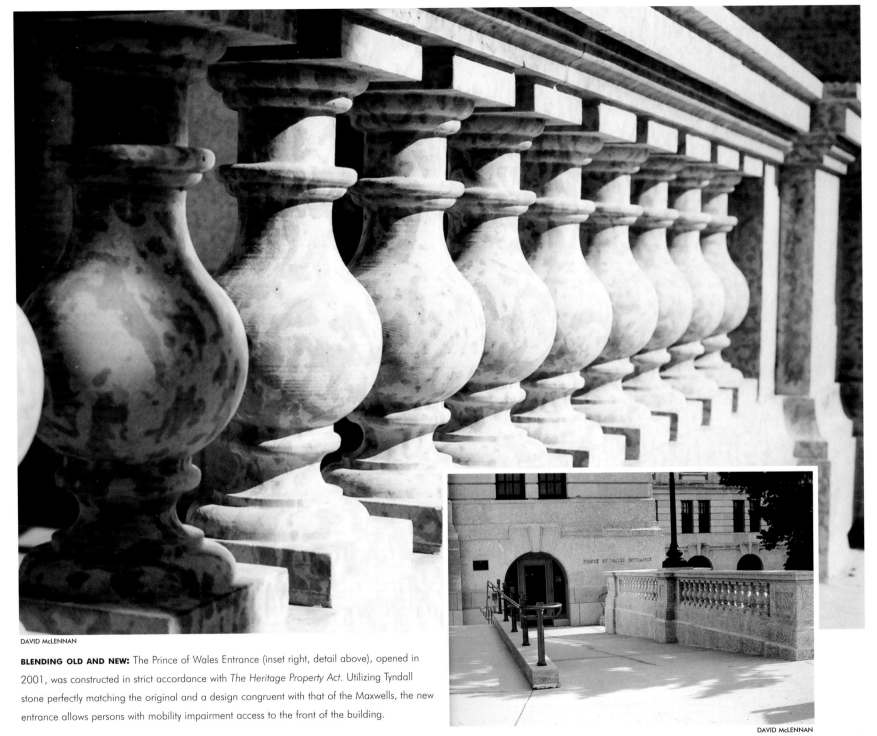

DAVID McLENNAN

BLENDING OLD AND NEW: The Prince of Wales Entrance (inset right, detail above), opened in 2001, was constructed in strict accordance with *The Heritage Property Act*. Utilizing Tyndall stone perfectly matching the original and a design congruent with that of the Maxwells, the new entrance allows persons with mobility impairment access to the front of the building.

DAVID McLENNAN

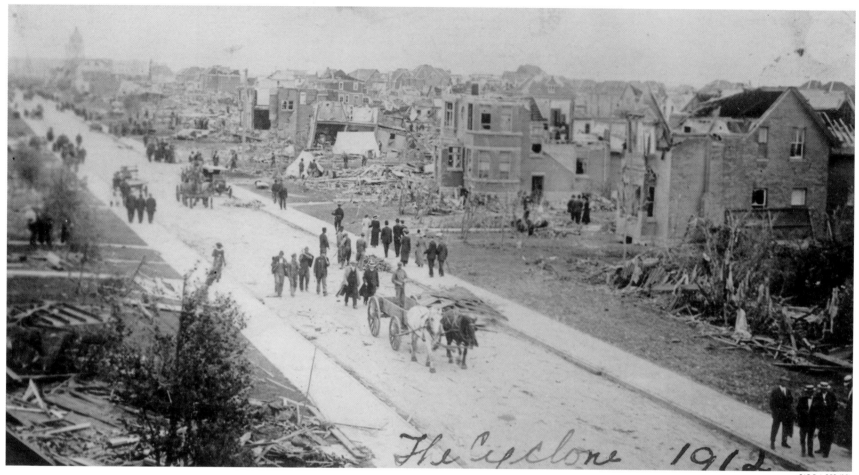

The Cyclone 1912

SAB R-A 858 (10)

THE "REGINA CYCLONE": On Sunday, June 30, 1912, a tornado side-stepped the near-completed Legislative Building causing relatively little damage. By comparison, however, the city itself to the north, was not so lucky. Brick and stone buildings in downtown Regina—three churches, both the YWCA and the YMCA, the new library, and the telephone exchange—were completely destroyed as winds reached an estimated 500 miles per hour. Within about three minutes, twenty-eight people were dead—including young Philip Steele, plucked from his canoe on Wascana Lake and hurled against the shore. Hundreds of people were injured, 2500 left homeless. Jute sacks from the Legislative Building construction site were found as far away as Victoria Park.

The worst damage to the new building occurred on the north face of the East Wing. The Department of Education was housed in this area, and that year's provincial final exams (just written) were scattered in the storm. As a result, Saskatchewan students in 1912 received a passing or failing grade based upon their teacher's recollection of the year's work.

Worse hit was the Legislative Library. The windows were blown out, and two large holes—twenty to thirty feet across—were knocked out of the interior walls. The contents of the library were a confused scramble of books, wood, paper, and plaster—and for seventy years afterwards, library patrons complained of cold winter drafts in the reading room until the windows were, at last, properly repaired in 1982.

The "Regina Cyclone" of 1912 remains on record as the worst in Canadian history.

THE COMPLETED BUILDING (1913) before the immediate grounds were landscaped is the backdrop for the construction timeline on the facing page. The digitally-colourised inset shows the building as it would have looked upon completion—its copper dome not yet having succumbed to oxidation.

Construction Timeline

September 1, 1905 — Saskatchewan becomes a province, and soon thereafter the new Scott government takes the decision to construct a capital building.

Spring, 1906 — James Alexander Calder begins to examine potential sites for the building's construction.

June 14, 1906 — Calder reports to Premier Scott that the "Old Sinton Property"—a 168-acre site south of the resevoir—is his recommendation. The government purchases the land from the McCallum Hill Company for $96,250.

1907 — Montreal landscape architect, Frederick Todd, is hired to determine the exact axis of the building and to begin plans for a park to surround the building.

The government announces it will have an architectural competition for the building's design. Percy Nobbs, professor of architecture at McGill University is hired as an advisor and to oversee the competition.

December 20, 1907 — The architectural plan of brothers Edward and W.S. Maxwell of Montreal is chosen as the winning design.

May 23, 1908 — Seeking a general contractor, the government advertises for tenders.

July 1908 — Contractors P. Lyall and Sons are hired.

1908 — Trees and shrubs are beginning to be planted throughout the area.

Fall 1908 — Drilling piles for the building's foundation begins.

October 4, 1909 — The cornerstone is laid.

November 23, 1910 — The first government departments move into the enclosed West Wing while the rest of the building is still under construction.

January 11, 1911 — The Legislative Assembly holds sessions in the reading room of the Legislative Library, as the Chamber is not yet complete.

January 25, 1912 — The first session is held in the Legislative Assembly Chamber.

June 30, 1912 — A tornado devastates Regina. Despite some damage, the Legislative Building emerges relatively unscathed.

October 12, 1912 — The Governor General, the Duke of Connaught, officially opens the building.

1913 — British landscape architect Thomas Mawson is hired to develop a comprehensive plan for a much larger park.

March 12, 1914 — The government makes its final payment to P. Lyall and Sons, and the project is officially complete.

SAB R-B 170 (2)

The Official Opening

"The significance of a building…is more than the cost, dimensions, material style, facilities, and the ingenuity of its planning. Basically it is an expression of human thought and will. The quality of its human or broad historical significance must be sought in the minds of its promoters."

—the Duke of Connaught, in his speech given at the Opening Ceremony, October 12, 1912.

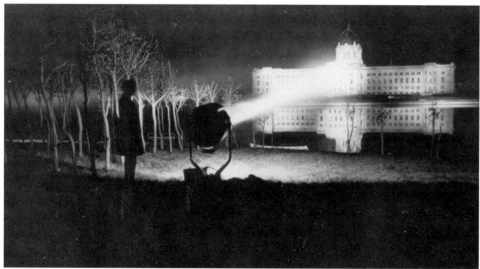

SAB R-A 6414

FOUR SEARCHLIGHTS illuminated the building for the opening ceremonies (above). Fireworks were also a part of the evening's celebration.

As construction of the Legislative Building neared completion, plans were underway for the official opening. A committee, composed of Spencer Page, Clerk of the Legislative Assembly, S.W. Carpenter, acting deputy minister of Public Works, and D.R. Reid, deputy provincial treasurer, began planning for the grand opening, with a $10,000 budget from the provincial government.

Bunting and miniature flags had been used at the laying of the cornerstone, in keeping with traditional festive practices at the time. However, for the opening ceremony, the committee wanted to add an element which would be symbolic of the future, and it was decided to make as much use as possible of electric lighting. The use of electricity—a relatively recent innovation—was spreading rapidly. Its incorporation into the ceremony would symbolize the most recent developments in technology and Saskatchewan's proud march into the twentieth century. As a result, searchlights were used to illuminate the building. In particular, the magnificent dome, which rose above the surrounding prairie, was highlighted for all to see.

A triumphal arch was constructed at the corner of 16th (now College) Avenue and Albert Street. From the arch to the Legislative Building, rows of electric lights were strung along poles. The excitement mounted as the day approached for the arrival of the new Governor General, the Duke of Connaught. Finally, on October 12, 1912, the Governor General and his party arrived in Regina by train. After a visit to Government House, the Governor General and his entourage moved on to the Legislative Building. As it was now early evening, the lights were all on to mark the route and to add to the excitement of the event. A host of people from Regina and the surrounding towns and countryside lined the parade route to welcome the Governor General and to witness the grand occasion. The official party proceeded to the Rotunda in the Legislative Building, which

was decorated with flowers and shrubbery. Walter Scott did not attend due to illness and his place was taken by J.A. Calder, the acting premier. An Indian peace pipe was presented to the Governor General, followed by speeches. The Governor General then moved into the Legislative Chamber to receive the public before retiring to the Executive Council Chamber for refreshments. When the ceremonies were complete, the Governor General retired to the official train car for the night. On October 14, he attended an official luncheon hosted by the province in the Legislative Chamber before departing Regina by train.

After four years of construction and only seven years after the formation of the province, the Legislative Building was ready for full occupancy. When the government made the final payment to P. Lyall and Sons on March 12, 1914, the Saskatchewan Legislative Building was finally complete.

Even though the building was a centrepiece for representative and responsible government, there had been some concern about the overall construction costs. In response to this criticism, Scott had written:

The policy adopted is to put up a Chamber and set up offices adequate for at least twenty-five years without additions and which may for a century yet be credible enough to form the main building on the Capital grounds. Disraeli said that nothing more completely represents a nation than a public building.

SAB R-B 169

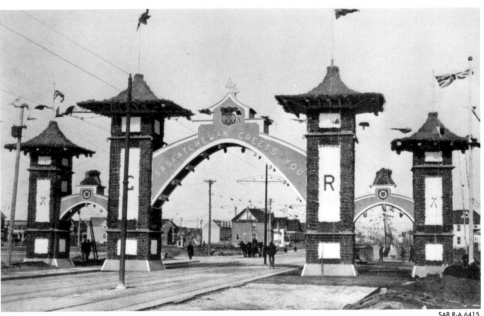

SAB R-A 6415

THE ENTOURAGE of Canada's Governor General, the Duke of Connaught, a son of Queen Victoria, passed en route to the opening ceremony through triumphal arches (above). The peace pipe (inset, left) presented to the Governor General during the ceremony has this inscription on a gold plate: "This Pipe of Peace was originally obtained from Onisasin Geesekow (Fine Day) of the See-See-Kwahmis Indian Reserve (Sweet Grass Reserve) and was presented to His Royal Highness the Duke of Connaught on the occasion of the Opening of the Legislative and Executive Building at Regina, on Saturday, October 12, 1912." While in Regina the Duke (seen below in top hat and cane) presided over another opening ceremony of another notable landmark—Regina College— on October 14.

UNIVERSITY OF REGINA ARCHIVES 75-16 (14)

43

Inside the Building

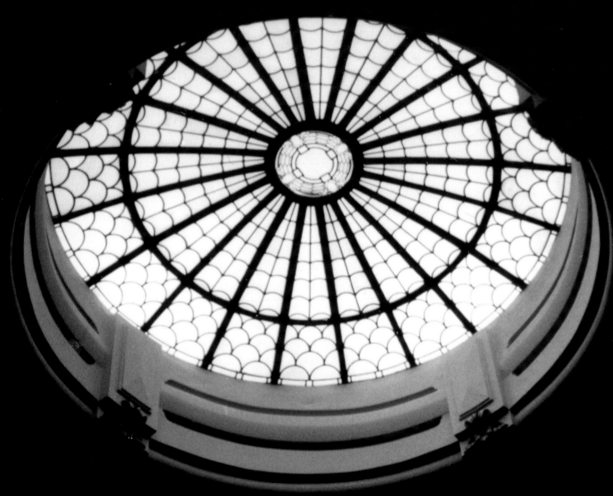

BEAUTY AND LIGHT: The false skylight above the Rotunda is one of the most striking features in the interior of the Saskatchewan Legislative Building.
DAVID McLENNAN

The same meticulous care and attention to detail was paid to the interior design of the new Legislative Building as had been the case with its exterior. The contract with W.S. and Edward Maxwell also included the design and selection of the interior fittings and furniture. In this capacity, they took special care to include beauty, skilled craftsmanship, and symbolism throughout the building. On one of their trips from Regina back to Montreal, the Maxwells stopped in St. Paul, Minnesota, to look at the new State Capitol Building and the furnishings within, in order to get ideas for the Saskatchewan building. No detail was deemed too insignificant for inclusion, and distinctive symbols of both Saskatchewan and Canada are to be found throughout the building, often in the least expected of places.

PREMIER'S PARLOR
ARM CHAIR

CANADIAN ARCHITECTURE COLLECTION, McGILL UNIVERSITY

PROVINCIAL GOVERNOR'S ROOM
DESK CHAIR

CANADIAN ARCHITECTURE COLLECTION, McGILL UNIVERSITY

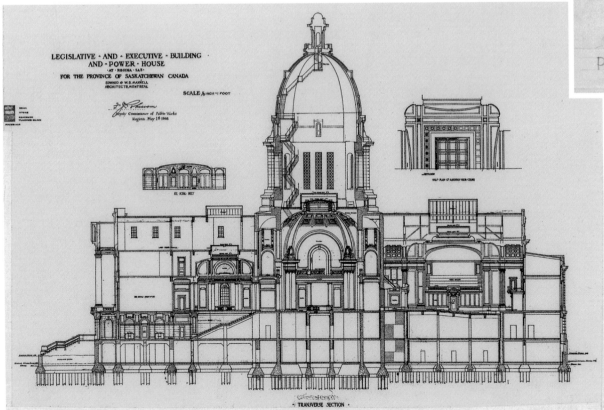

CANADIAN ARCHITECTURE COLLECTION, McGILL UNIVERSITY

PLANS: The architects' papers housed in the Canadian Architecture Collection at McGill University include detail drawings of furniture for the Legislative Building. The above examples, executed in watercolour, show an arm chair for the premier's parlor (above left) and a desk chair for the lieutenant governor's room (above right). The architect's 1/8" scale transverse view of the building (left) reveals interesting aspects of the building's design—the reflective enclosures housing the electric lamps above the artificial skylights over the Chamber, the Rotunda, and the Grand Staircase; the twisting route to the final spiral staircase leading to the lookout at the top of the dome; and the mass of piles concentrated beneath the weight of the building's central core.

45

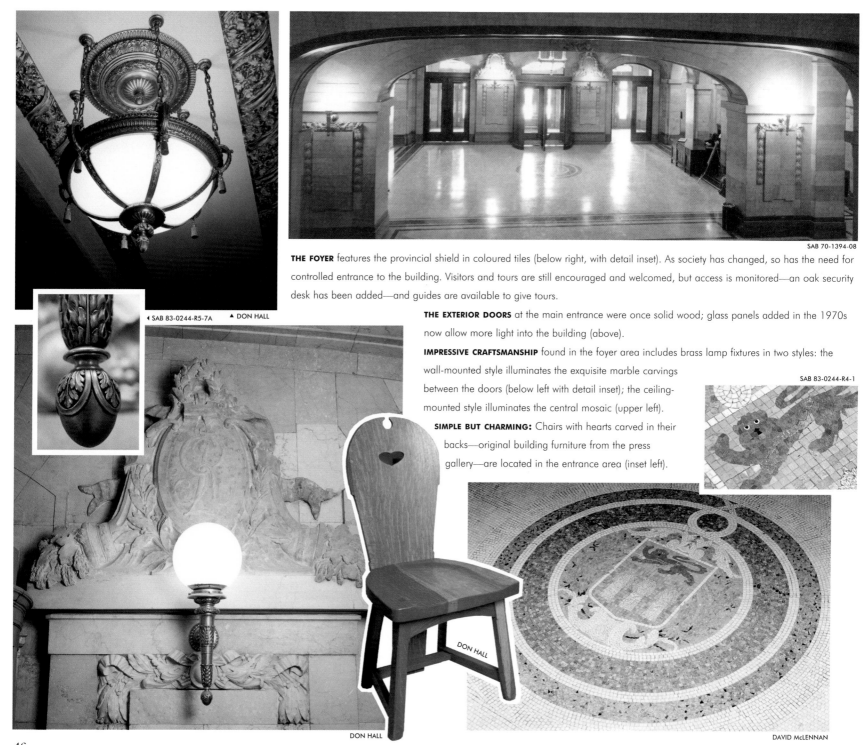

SAB 70-1394-08

◄ SAB 83-0244-R5-7A ▲ DON HALL

SAB 83-0244-R4-1

THE FOYER features the provincial shield in coloured tiles (below right, with detail inset). As society has changed, so has the need for controlled entrance to the building. Visitors and tours are still encouraged and welcomed, but access is monitored—an oak security desk has been added—and guides are available to give tours.

THE EXTERIOR DOORS at the main entrance were once solid wood; glass panels added in the 1970s now allow more light into the building (above).

IMPRESSIVE CRAFTSMANSHIP found in the foyer area includes brass lamp fixtures in two styles: the wall-mounted style illuminates the exquisite marble carvings between the doors (below left with detail inset); the ceiling-mounted style illuminates the central mosaic (upper left).

SIMPLE BUT CHARMING: Chairs with hearts carved in their backs—original building furniture from the press gallery—are located in the entrance area (inset left).

DON HALL

DON HALL

DAVID McLENNAN

THE GRAND STAIRCASE, or "Staircase of Honour" (right), leads from the foyer to the Rotunda, the intersection of the building's East-West and North-South axes. The red carpet running the centre of the tiers indicates that the Legislative Assembly is in session—when the session closes, the carpet will be rolled up and put away until the next sitting. Above the Grand Staircase, a vaulted ceiling (below) adorned with gilded plaster roses and maple leaves creates a sense of spaciousness and grandeur.

DON HALL

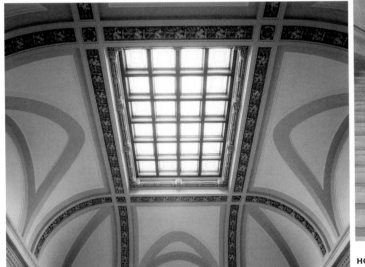

ARNOLD McKENZIE ▲

HOW FITTING that in the entrance to the province's house of democracy, tribute is paid to those who fought to preserve freedom and liberty. Above the Grand Staircase, and in alcoves on either side of the bottom of the stairs, maquettes by Regina architect, Frederick Chapman Clemesha, occupy places of honour. Clemesha, who was wounded serving in the Canadian Corps during the First World War, created the maquettes in 1921 for Canadian Battlefields Memorials in Europe. His design was used to create one of the most impressive monuments on the Western Front—the St. Julien Memorial near Ypres. Towering over the surrounding countryside, the monument is visible for several miles, and commemorates 2000 Canadian soldiers buried below, who died in the first gas attacks of the war which occurred April 22–24, 1915.

DON HALL

◀ SASKATCHEWAN LEGISLATIVE BUILDING ART COLLECTION ▲

The Rotunda

"At the head of the Staircase of Honor, which is of spacious proportions, with a lofty vaulted ceiling, one steps into the ante-room of the Legislative Chamber, situated beneath the dome from which it receives its light, and on the major and minor axes of the building. To this room has been assigned an importance second only to that of the Chamber itself, with its monumental treatment, spacious vertical and horizontal vistas."

—*from the Architects' Report*

The Rotunda (referred to on the plans as the "antechamber") is one of the most spectacular interior features of the Legislative Building, and the Maxwell brothers deliberately designed it with an arched ceiling under the dome to create a sense of beauty and grandeur. Through the Rotunda, one is led directly to the Legislative Chamber, the focal point of the Legislative Building, where decisions affecting the future of the province are debated. Ironically, because of the location of their respective offices, MLAs from both sides must first meet in the Rotunda on their way to do political battle in the Chamber!

CANADIAN ARCHITECTURE COLLECTION, McGILL UNIVERSITY

DON HALL

LIGHTING in the Rotunda is provided primarily by the magnificent faux skylight above its centre; the lower level is also adorned with simple, yet elegant, brass lamps (left). The 20 x 24 foot arched mural over the main doors to the Legislative Chamber (in the photo right) is entitled "Before the White Man Came." John Leman, an employee of the Department of Public Works, created the piece in 1933. The painting depicts a hunting party in the Qu'Appelle Valley preparing to attack a buffalo herd on the opposite side of the lake. The photograph on the facing page (from the architect's collection of papers) predates the painting of the mural. While Edward and W.S. Maxwell described the exterior of the building as a "free adaptation of English Renaissance" architecture, many elements of the Louis XVI French style were incorporated within. An example is the well in the centre of the Rotunda (pictured right). Constructed of Swedish marble, it resembles the tomb of Napoleon in Les Invalides in Paris. The well is often filled with flowers for special occasions, such as the opening of the Assembly or a Royal visit (below).

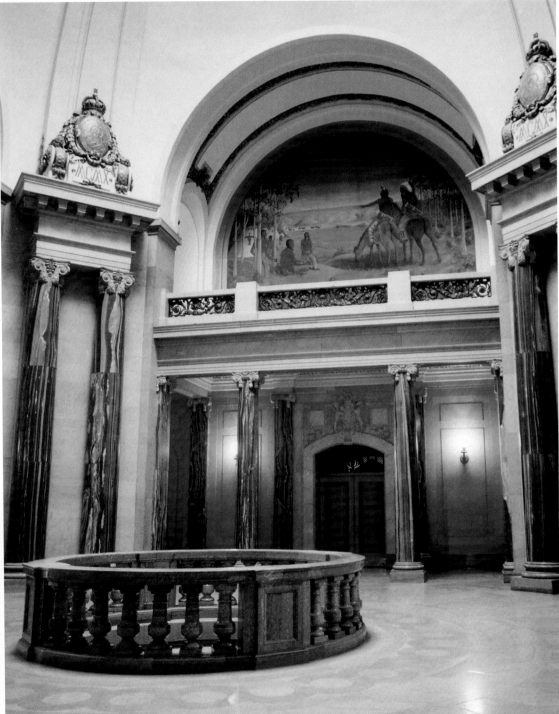

SAB 88-2381-R4-7A

SAB 86-1007-21

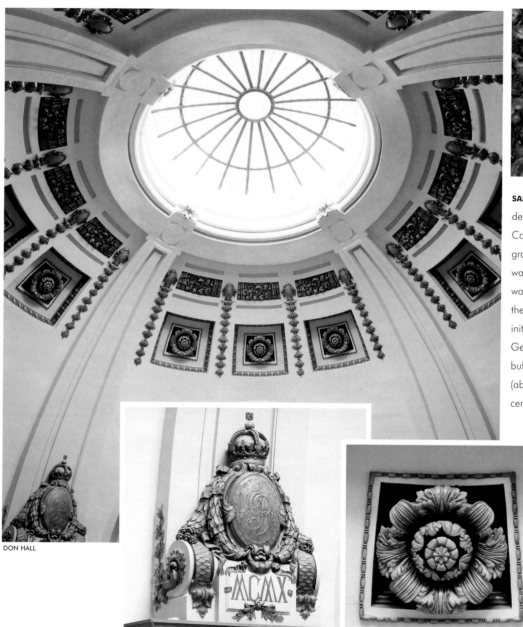

DON HALL

DON HALL

SASKATCHEWAN'S DEEP TIES with the British monarchy are evident in design details throughout the building. Beneath the exquisite marble carving of the Canadian Coat of Arms (below) and above the Chamber doors, a metal grate features the initials "ER" (for *Edwardius Rex*), since the King at the time was Edward VII. Edward died in 1910, however, and so the Rotunda, which was then under construction, also recognizes his heir. In the four corners of the Rotunda, atop the pillars, are four plaster crowns (inset far left) with the initials "GR" (for *Georgius Rex*) and the date MCMX (1910)—the year that George V came to the throne. Other design details include plaster figures of buffaloes which overlook the balcony around the Rotunda's second floor (above) and gilded rosettes (left and inset) which surround the impressive central dome.

DON HALL

DON HALL

TRIBUTES IN BRONZE: Prominently featured in the Rotunda are three bronze busts commemorating political leaders who have secured their place in history serving both Saskatchewan and their country with great distinction. The bust of John Diefenbaker (left), Prime Minister of Canada from 1957 to 1963, was sculpted by the world-renowned Winnipeg artist, Leo Mol, an Officer of the Order of Canada. The work was a gift from the late prime minister to the Province of Saskatchewan. The busts of Walter Scott, Saskatchewan's first premier, from 1905 to 1916 (centre), and notable premier T.C. Douglas, 1944 to 1961 (right), were commissioned for Saskatchewan's millennium celebrations in 2000 (the bronze of John Diefenbaker was also restored at this time). Hans Holtkamp of Saskatoon created the bust of Scott, while Susan Velder of St. Walburg sculpted the likeness of Douglas. Velder has recently another prestigious commission from the Provincial Government. To commemorate the Queen's Golden Jubilee in 2002, Velder will create a bronze statue of Queen Elizabeth II to be placed on the grounds of the Legislative Building. The Queen will be depicted riding her favorite horse, Burmese, which was a gift from the Royal Canadian Mounted Police.

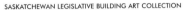

SASKATCHEWAN LEGISLATIVE BUILDING ART COLLECTION SASKATCHEWAN LEGISLATIVE BUILDING ART COLLECTION

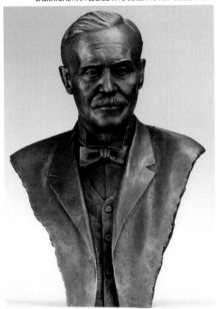

SASKATCHEWAN LEGISLATIVE BUILDING ART COLLECTION

"A MASTERPIECE IN MARBLE" is perhaps the best way to describe the three-storey Rotunda. Its eight large marble columns are eight metres in height; each weighs 4,500 kilograms or 9,918 pounds (tour guides in the building routinely explain to visitors that this is the approximate weight of an African bull elephant). The Rotunda's sixteen smaller marble columns are five and a half metres high and weigh 3,200 kilograms or 7,052 pounds each. The green and white marble for these pillars was quarried on the island of Cyprus, then cut and shaped in Quebec. The floors of the Rotunda are of marble from Vermont, the walls of Italian marble, and the baseboards and the bases of the columns come from Ireland. The Grand Staircase leading up to the Rotunda is of a white veined marble from Philipsburg, Quebec. In all, the Legislative Building has an estimated 34 different types of marble from around the world.

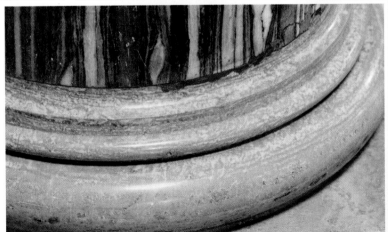

SAB 83-0244-R3-15A SAB 83-0244-R3-16A

51

The Legislative Chamber

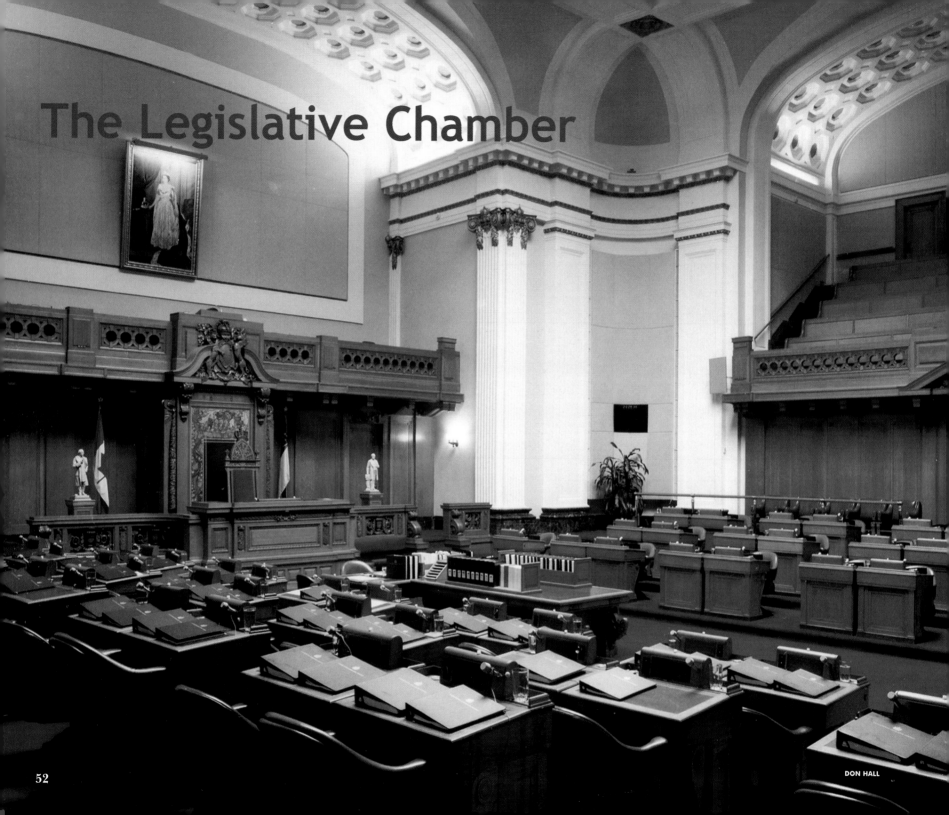

52

DON HALL

From [the Rotunda] the Legislative Chamber is approached by a main central entrance, and by two flanking entrances, thus providing ample circulation during a crowded session. This room has been designed after making a careful study of the principal examples of successful rooms of a like character, and it is believed will fulfill its functions in a manner capable of but slight improvement. An unobstructed view of the Speaker's rostrum from every seat in the house is obtained, as well as from every seat in the public galleries, provided on the three sides of the room. The Speaker's and press galleries are likewise well situated behind and above the speaker and approached by two stairways off the rear corridor....

It will be noted that from the point at which one enters the building by the main entrance vestibule, hall, staircase of honor and ante-room, a succession of monumental apartments are traversed, all leading directly to the Legislative Chamber, the room above all others for which this building will be erected.

—*from the Architects' Report*

DON HALL

OAK is the unifying theme in the Legislative Chamber (facing page). Matching carvings of the provincial coat of arms flank the main doors into the Chamber (above). Although these carvings were added later, they match perfectly with the original oak panelling and the oak members' desks (below).

DON HALL

While the Rotunda is predominantly marble, the Legislative Chamber is mainly wood—the members' desks, the paneling on the chamber walls, and the public galleries are all crafted of fine oak. Visitors' galleries are on the east and west side of the chamber while there is a gallery reserved for the Speaker's guests and another for the members of the media.

When renovations were underway in the building in 1978, it was found that the oak in the chamber had darkened due to age and dirt, that the sound system needed to be replaced, and that the roof above the chamber was leaking. A Regina architect, Clifford Wiens, was engaged to plan and oversee the refurbishment project. A committee comprised of Members of the Legislative Assembly was established to co-ordinate the refurbishment of the chamber and the purchase of a new sound system. The 1978 refurbishment project also led to some research about the chamber as it was originally designed: see the "carpet controversy" on page 55, the "mystery of the dais" on pages 58 and 59, and the story of the first Speaker's chair on pages 60 and 61.

DON HALL

A ROOM OF SYMBOLS: The Legislative Chamber is a crown-shaped room (facing page), and crowns adorn the corners (this page, top left). Throughout the Assembly, images of the monarchy abound. The initials of King George V are carved in the oak on the speaker's dais, and the portrait of the sovereign has always hung at the head of the house above the Speaker's chair. But perhaps nothing in the Legislative Chamber symbolizes the supremacy of the throne more than the mace (below). Originally used as weapons in medieval times, maces were carried by sergeants-at-arms (the royal bodyguards). Today, the mace has a ceremonial role and represents the Speaker's authority in the Assembly. Gold plated, 1.2 metres long, and weighing 16 kilograms, it is carried into the Chamber at the beginning of each day's session, and remains as long as the Speaker is in the Chair. Purchased in 1906, Saskatchewan's mace

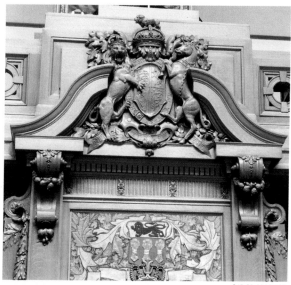
SAB 81-1195-100

DON HALL

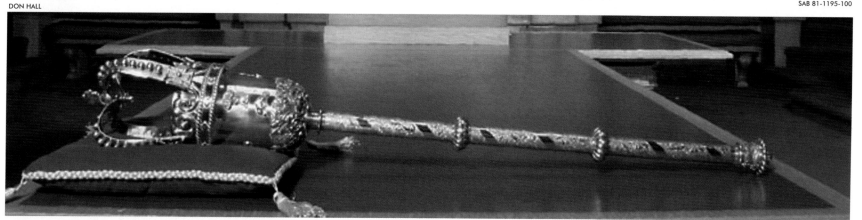

GOVERNMENT OF SASKATCHEWAN

DON HALL

bears the Royal coat of arms and motto, *Honi soit qui mal y pense* ("Evil be to him who evil thinks"). A second inscription, *A mari usque ad mare* ("From sea to sea") is the motto from the Canadian coat of arms. The mace is further decorated with other images representative of both the country and the province—beavers and wheat sheaves. Symbols of Canada and Saskatchewan are found throughout the Legislative Chamber: the Canadian coat of arms surmounts the dais (top right), the exquisite sculptures of Sir John A. Macdonald and Sir Louis Lafontaine command the front of the house (see page 56), beavers and wheat sheaves again appear, carved in the oak detailing (left), and on either side of the Speaker's chair are the Canadian and Saskatchewan flags.

CLERKS OF THE LEGISLATIVE ASSEMBLY

Samuel Spencer Page	1906–1916
George Arthur Mantle	1917–1939
John Mason Parker	1939–1949
George Stephen	1949–1960
Charles Beverley Koester	1960–1969
Gordon Leslie Barnhart	1969–1989
Gwenn Ronyk	1989–present

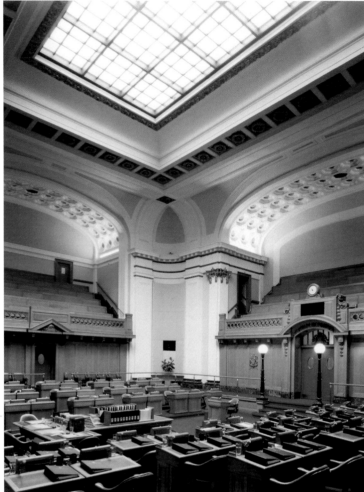

DON HALL

The question of galleries is usually the "bête noire" of architects in designing a legislative chamber. They either extend to undue proportions the size of the room, rendering it difficult to arrive at a satisfactory architectural solution; whereas, if made to overhang into the room the view of the public and members is unduly restricted by the unsightly projections. In this design the usual objectional form of the galleries has been overcome by placing each one in a recess specially provided for it in the architectural treatment of the room, unnecessary size and consequent acoustic difficulties being thereby avoided.

—from the Architects' Report

Red Green: The Carpet in the Chamber

Traditionally, the colour of the carpet in parliamentary buildings has been green for the Lower House (the House of Commons) and red for the Upper House (the House of Lords in Britain or the Senate in Canada). However, the carpet in Saskatchewan's Legislative Assembly Chamber has always been red—a break with tradition which has been debated for nearly three-quarters of a century.

Green was the colour of choice of the Maxwell brothers, as is evident in their letter of December 8, 1910, to F.J. Robinson, Deputy Minister of Public Works, in which they suggested textures and quality of carpeting that should be used in the Chamber. The architects had planned the building with a green theme throughout, from the marble in the rotunda to the green marble baseboards in the Chamber. They wrote: "For the Assembly Hall, our preference is a soft firm green which will harmonize very beautifully with the oak trim." They went on to qualify their suggestion for green by saying that they had "no great objection to offer" if red was preferred. The architects concluded their letter by enclosing a small sample of green carpeting which they considered to be "a practicable and desirable color." For reasons unknown, the recommendation of green carpeting was overruled and red carpeting was installed. When the carpet was replaced approximately four decades later, red again was chosen.

In 1978, when the entire room was in need of repair and refurbishment, the architect overseeing the project urged that green carpet be installed to match the oak and the green marble baseboards in the chamber. The committee endorsed this recommendation and reported the same to the Legislative Assembly. The Assembly adopted the committee's report and it appeared that the chamber would finally return to the parliamentary tradition of having green for the elected House. However, the Minister of Supply and Services overruled all recommendations and ordered red carpet, reasoning that green was inappropriate since it was the colour of the Liberal Opposition. Ironically, it had been a Liberal government in 1910 that chose red! Why that choice was made remains a mystery.

RECOVERED TREASURES: Serendipity has been responsible for the recovery of numerous objects in the Legislative Building—the chair of the Speaker of the first Legislative Assembly of Saskatchewan, the front of the original dais in the Legislative Chamber, a fireplace enclosed within a wall, a grandfather clock, and the statuettes pictured below. A letter from the Legislative Assembly Office (excerpt below) tells the story of these sculptures, and how they have come to occupy their places of honour for nearly 70 years.

March 7, 1933.

The Hon. James F. Bryant, K.C., Minister of Public Works, has today placed in the Legislative Assembly the statuettes of Sir John A. Macdonald and Sir Louis Lafontaine, on pedestals on either side of the Speaker's chair. Before the Orders of the Day were proceeded with, Mr. Bryant stood up in the House and said:

Mr. Speaker: I desire to call the attention of the honorable members of this House to the fact that with your consent, I have caused to be placed on the Speaker's dais, this day, portrait statuettes of Sir John A. Macdonald and Sir Louis Lafontaine, two great Canadians, executed by the famous French Canadian sculptor, Louis Philippe Hebert.

Mr. Hebert was noted for his statues of great Canadians. Returning to Canada after pursuing his studies in Paris, he won the first prize in a competition instituted by the Federal Government, for a statue of Sir George E. Cartier... Among his other notable works are the statues of Sir Alexander MacKenzie and Sir John A. Macdonald at Ottawa, Maisonneuve and Laval monuments at Montreal, the Champlain monument at Quebec, the Joseph Howe statue at Halifax and the group of members of the Parliament of Quebec. Many of his numerous works of art were inspired by important incidents in the French regime in Canada...

The two statuettes were presented to the Government of the Northwest Territories and were kept in the old Government House or the old Legislative Building. The statuette of Lafontaine was executed in 1885, and that of Macdonald in 1886. These works of art were thrown into the discard. Last week, I found the broken and chipped statuette of Macdonald in the legislative vault where it had huddled under the bottom shelf for many years. I located in a corner under a table in the paint shop the statuette of Lafontaine and on inquiry found that it had been brought over there from among some lumber and junk in the old Power House. On examination, I found the signature of Hebert and the year on which they were created on the statuettes. I have had them repaired by the Government painter and believe that they are worthy of a place in the Legislature of Saskatchewan.

SASKATCHEWAN LEGISLATIVE BUILDING ART COLLECTION

SASKATCHEWAN LEGISLATIVE BUILDING ART COLLECTION

56

T. C. Douglas January 23, 1957.

Honourable C.G. Willis

Portrait of Her Majesty

 With reference to the picture of the Queen which
is presently in the Council Chambers I think some
consideration should be given to the possibility of
hanging it in the Legislative Chamber. The pictures
there are so ancient that the most recent one is of
King George V who died in 1935. This might be more
appropriate than having it in the Executive Council
Chamber.

OD:ew T. C. Douglas

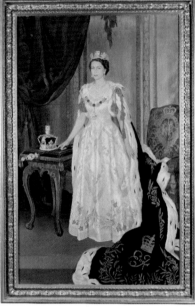

SASKATCHEWAN LEGISLATIVE BUILDING ART COLLECTION

REDECORATING: Sometimes it just takes awhile to get things done. A photograph taken in 1949 (left) shows that the portrait of George V was still displayed in the Chamber—thirteen years, and two monarchs—after the King's death. Eight years later, and just two weeks shy of Elizabeth II's fifth anniversary as Queen, Premier Tommy Douglas suggested that perhaps the time had come for a change (memorandum inset). Finally on July 6, 1959, a portrait of HRH Queen Elizabeth II was unveiled and hung in the Legislative Chamber. However, this was not the painting suggested by the premier, as a newer official portrait had since been completed. The portrait above (which still hangs in the Chamber today) was painted by John Alford and is an official reproduction of James Gunn's original painting.

SAB 4,810

The Mystery of the Dais

DON HALL

For many years the Speaker's dais in the Chamber was open in front, with an intricately carved balustrade on either side. Leading up to the dais was a set of stairs. In order to fill the open centre of the dais, a heavy oak table was customarily placed in front of Speaker. When the Legislative Assembly was preparing for special occasions involving the presence of the Lieutenant Governor—such as an opening, Royal Assent or prorogation—the table was removed and replaced by a ceremonial chair.

Even though the stairs and the dais had the appearance of being unfinished, it was believed that this was the original design. During the refurbishment of the Legislative Chamber in 1978, however, a photograph taken on January 25, 1912, of the members sitting in the new Legislative Chamber for the first time, was examined. From the photograph, it was discovered that the original dais was a complete unit and ran directly in front of the Speaker. When and why had the dais been altered, and where might the missing piece be located?

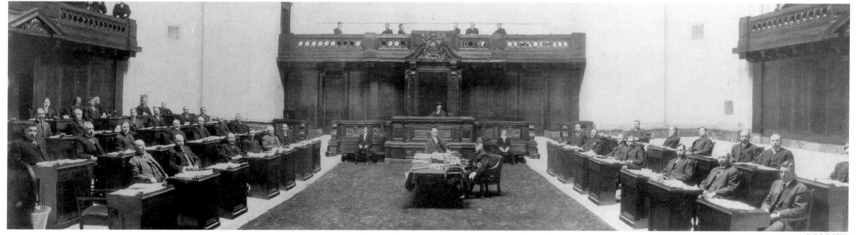

SAB R-B 2797

THE FIRST SESSION in the Chamber opened on January 25, 1912 (above) and closed March 15. Although Walter Scott was Premier at the time, he was not in the House when this picture was taken. The Speaker, Honourable W.C. Sutherland, sits at the dais as it was originally constructed. According to ancient parliamentary tradition, the mace is the symbol of the Speaker, and when the House is in session, it lies on a table with its head pointing to the government side. In the photograph shown here, however, the mace was inadvertently placed with its head pointing towards the Opposition side of the House.

Since the refurbishment in 1978 was designed to restore the chamber to its original condition, it was decided that the original dais should be located or a new one built. After an extensive search through storage rooms, the missing piece of the dais was found in the dome of the Legislative Building. It had been exposed to the ravages of pigeons and the elements for many years and at first looked to be beyond repair. Fortunately, thanks to the skills and patience of the wood refinishing craftsmen in the Department of Supply and Services, the dais was restored and returned to the Legislative Chamber.

But why it had been removed in the first place? Had it been taken out for a ceremony and not returned? This was unlikely, since the original dais was a permanent structure made of sturdy oak. Then, on reviewing archival photographs, it was noticed that the first appearance of the incomplete dais was in 1921, during the Speakership of George Scott. It appears that Scott was a man of small stature and the missing portion of the dais had apparently been removed so that Speaker Scott could see over it and give the appearance of being in control of the Assembly. The stairs were quickly built with the intention of restoring the complete dais at the end of Scott's Speakership. However, instead of going into "temporary storage," the dais actually languished in the dome for almost sixty years until its return to the Chamber in 1978. The refurbished dais is now back in the Legislative Assembly and is the central focus of the Chamber.

SAB R-B 273

MYSTERY SOLVED: The photograph above provided the clue necessary to explain the altered dais. Pictured are the Honourable George Scott, Speaker, and Mr. George Mantle, Clerk of the Legislative Assembly (foreground). The carvings (facing page, top left, and below) are from the speaker's dais—woodwork likely produced by the craftsman Thomas Middleton Pryde, who was responsible for much of the carving in the Chamber. Pryde's tools are now housed among the many artifacts in the Legislative Library.

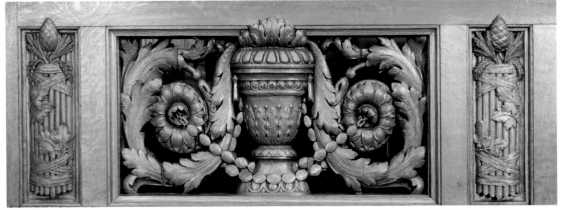

DON HALL

The Speaker's Chair

Although much of the original furniture from the Legislative Building has been worn out or lost over time, enough has been restored to show the care and attention to detail paid by Scott and the Maxwells. Interestingly, there are also some cases of furniture having been lost and then found again years later. The grandfather clock in the cabinet chamber is one example (see page 67). Another is the Speaker's Chair.

When the North-West Territorial Council met for the first time at Fort Livingstone in 1877, the Lieutenant Governor acted as the chairman of the meeting. All members of the Council were appointed rather than elected. However, as the territory gained in population, it also gained some measure of independence from the federal government, and in 1888 the Honourable H.C. Wilson was elected as the Speaker of the new Legislative Assembly of the North-West Territories.

Within the British parliamentary tradition, it was customary to carve a throne-like chair for the Speaker. When the Speaker left his post due to resignation or defeat, the chair was presented to him and a new chair was built for the incoming Speaker. The last occasion of this practice in Saskatchewan took place when the Honourable Thomas MacNutt (first Speaker of the new province of Saskatchewan, from March 29, 1906 to July 20, 1908) retired from provincial politics to run in a federal by-election. The Speaker's chair was presented to him and was kept in the family home in Saltcoats.

In 1965, the MacNutt family presented the chair to the Legislative Assembly. Because a permanent Speaker's chair was in place in the Legislative Assembly by this point, the MacNutt chair was placed on display in the reading room of the Legislative Library.

The history of this chair does not end there. The chair was loaned to the University of Regina from time to time for convocation ceremonies and was on one occasion, crated and flown to Yellowknife, N.W.T. for use by Governor General Roland Michener for a special ceremony.

THOMAS MACNUTT (1850–1927)

SAB R-B 449

In 1978, during a full refurbishment of the Legislative Chamber, it was decided to return the MacNutt chair to its original purpose as the chair used by the Speaker of the Legislative Assembly. As part of the chair's refurbishment, an extra layer of padding was inserted on the backrest of the chair, thus forcing the occupant to sit farther forward. The original design was very awkward for the Speaker, who would frequently catch the corner of his tricorn hat on the back of the chair when he turned his head. The change to the backrest now allows the Speaker to sit comfortably, without the frustration of having his hat constantly being knocked askew.

Ironically, when the chair was returned to the Chamber in 1979, this marked the first time

SAB 80-628-98

60

that this specific chair had been used in the Legislative Chamber. When Thomas MacNutt was Speaker, the Legislative Assembly met in the Legislative Building on Dewdney Avenue and then in the old Post Office on the corner of Scarth Street and 11th Avenue. While the chair was never used in the present legislative chamber during MacNutt's tenure as Speaker, it is fitting that the chair of the first Speaker of the Legislative Assembly of Saskatchewan became the permanent chair of the Speakers since 1979.

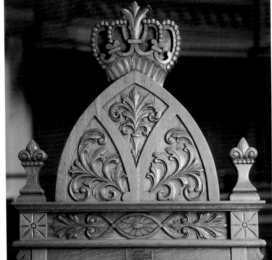

DON HALL

THE EXQUISITE GOLD TAPESTRY behind the Speaker's chair (far left) was embroidered by two Sisters from a Montreal convent. The refurbished MacNutt chair (below) has the traditional crown-shaped top (detail left).

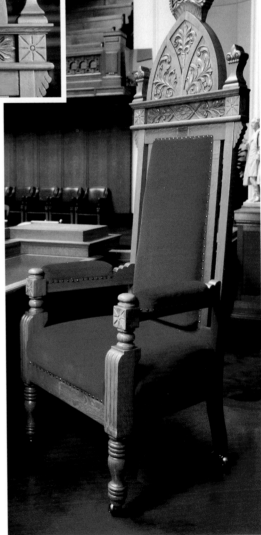

HISTORICALLY SPEAKING: The origin of the Speakership as a part of British parliamentary tradition dates back to 1377, the beginning of the reign of Richard II. The Speaker's duty was originally to represent the monarch's views to parliament—thus the throne-like design of the Speaker's chair surmounted by a carving of a crown. With the English Civil War, however, and the execution of Charles I in 1649, the role of the Speaker was, in a sense, reversed: he was now considered a servant of the parliament, representing the interests of the members to the monarch. For a number of years, however, the role of the Speaker remained rather precarious—not to mention dangerous. Being chosen Speaker was therefore accepted with great reluctance, which is why today we see the traditional performance of the leaders of the Government and Opposition parties firmly escorting "resistant" new Speakers to the dais.

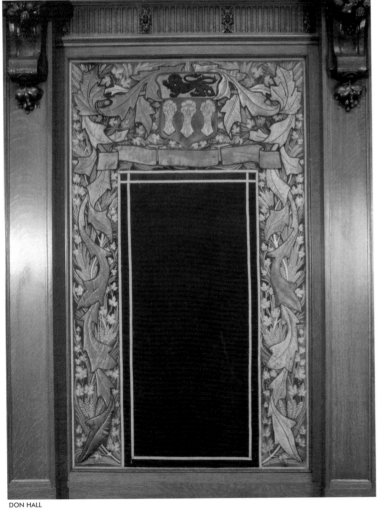

DON HALL

DON HALL

The Premier's Office

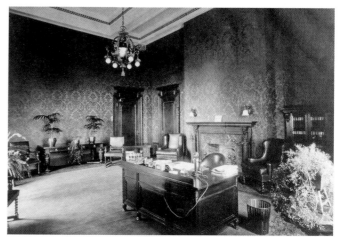

SAB R-B 287 (1)

DON HALL

Located on the second floor of the North—or "Executive"—Wing of the building is the Premier's Office. Being the "premier" office in the building, it is centrally located and spacious, formal yet functional. While the furnishings, carpets, and draperies have been changed over the years, the office has retained its original elegance and warmth.

To date, the office has served thirteen premiers: T. Walter Scott, 1905–16; William M. Martin, 1916–22; Charles A. Dunning, 1922–26; James G. ("Jimmy") Gardiner, 1926–29, 1934–35; J.T.M. Anderson, 1929–34; William J. Patterson, 1935–44; T.C. ("Tommy") Douglas, 1944–1961; Woodrow S. Lloyd, 1961–64; W. Ross Thatcher, 1964–71; Allan E. Blakeney, 1971–82; D. Grant Devine, 1982–91; Roy J. Romanow, 1991–2001; Lorne A. Calvert, 2001 to present.

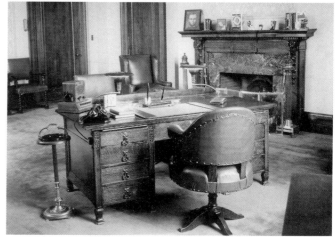

SAB 56-118-06

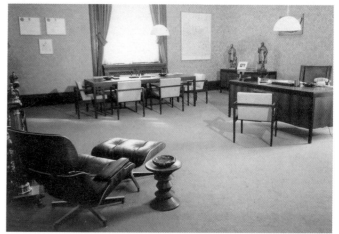

SAB 66-962-08

THROUGH THE YEARS: An early photograph shows the premier's office, date unknown (top right). In 1956 (middle) the office was occupied by T.C. Douglas, who for seventeen years—longer than any other premier—served the Province of Saskatchewan. Reportedly, Premier Douglas often used the fireplace, feeling quite at home in the office. Family portraits sat on the desk and mantle of the fireplace, and interestingly, a photograph of Abraham Lincoln. The office of Ross Thatcher (bottom) in 1967 reflects the changing times and tastes. Above left, the brass doorknob for the premier's office features the Saskatchewan coat of arms.

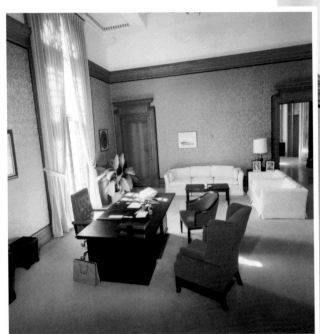

SAB 80-628-60

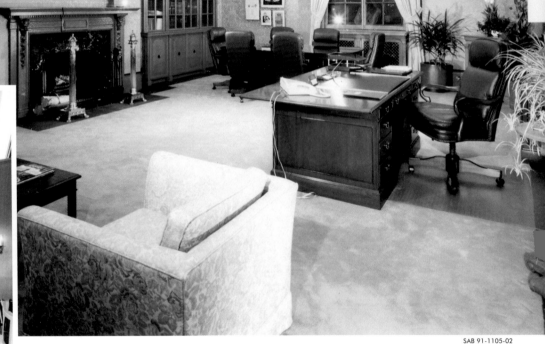

SAB 91-1105-02

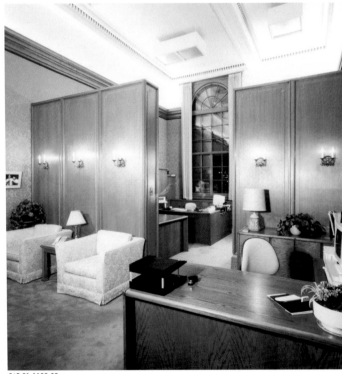

SAB 91-1105-09

THE "PREMIER" OFFICE: The photograph of Premier Allan Blakeney's office (top left) taken in 1980 shows, on the right side, the hallway leading to the Rotunda and the Legislative Chamber beyond. The premier's outer office (bottom left) and inner office (above) are depicted as they are today.

Executive Quarters

SAB 83-3057-R1-2A

D own the hall from the Premier's Office are the Cabinet Room and the Cabinet Lounge. While the Cabinet Room was in the Maxwell brothers' original floor plan, the Cabinet Lounge was initially, and for many years, the "apartment" of the Lieutenant Governor. Today, the room is used as a lounge during Cabinet meetings and as a meeting room both for Cabinet committees and for the Premier.

THE CABINET ROOM (far right) is finished in oak and panelled with a rich red brocade tapestry. The ceiling is decorated with gilded plaster, and the carpets—specially woven for the room—are embroidered with Western Red Lilies and the provincial shield.

AN ORNATE PARCHMENT commemorating the first meeting of the Executive Council hangs in a corner of the Cabinet Room (right). The illumination and calligraphy were the work of the renowned artist, James Henderson.

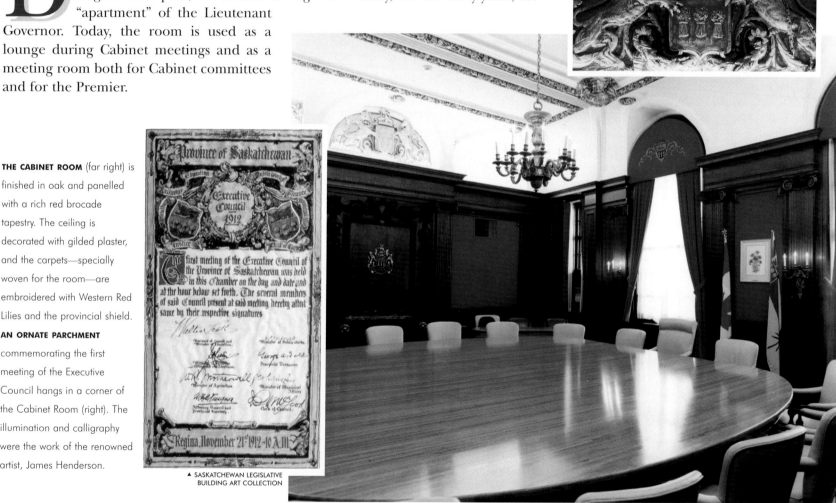

▲ SASKATCHEWAN LEGISLATIVE BUILDING ART COLLECTION

DON HALL

64

SAB 83-3057-R1-18A

SAB 83-3057-R2-8

SAB 59-063-08

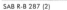

DON HALL

EXQUISITE DETAIL can be found in the fixtures and furniture of the Cabinet Room. The carving above the fireplace (facing page, top) and the brass candelabra (above left, detail to the right) are examples of the fine craftsmanship. The armchairs (left) once used in the Cabinet Room, while comfortable and utilitarian, are also intricately—perhaps somewhat whimsically—designed. Each has two owls carved in its arms (inset), representing wisdom—an important quality in a cabinet minister. These chairs, however, as well as the original circular cabinet table, are now located elsewhere in the building—as cabinet grew, more chairs and a larger table were required. A photograph (above right) shows the room in 1959 with its "newer" furniture and the once ubiquitous black ashtray. Four of the "owl" chairs now reside in the Speaker's suite, and the old cabinet table is located in the cabinet lounge (below right). The photograph below shows the Cabinet Lounge when it was still the office of the Lieutenant Governor.

DON HALL

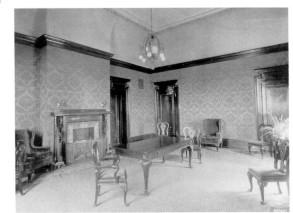

SAB R-B 287 (2)

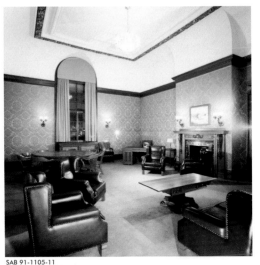

SAB 91-1105-11

65

Keeping Warm...

In designing the interior furnishings of the Legislative Building, particular attention was paid to the design of the fireplaces which, to be sure, were of central importance in the heating of the building in the early years of the twentieth century. Functional and ceremonial, all of the fireplace mantles, with two exceptions, were carved out of oak. The oak fireplaces are to be found in ministers' offices, meeting rooms, the Legislative Library reading room (below, left) and the cabinet room (right and far right). On the other hand, the fireplace mantle and the wood trim in the Lieutenant Governor's suite were fashioned from mahogany—representing, perhaps, the unique role of the Lieutenant Governor in the governance of the province (below, right). The other non-oak fireplace was discovered in the basement of the building during renovations conducted in the 1980s. Located in the Members' "smoker"—a lounge off the Members' dining room—this fireplace, which was constructed from red tile, with a mantle incorporating the design of an Indian, evidently went out of service at some point (below, centre). However, rather than being dismantled, it was enclosed within a wall, perhaps to preserve it for the future. It has now been fully restored. No explanation has been found for the fact that this fireplace, unlike any other, was constructed from tile.

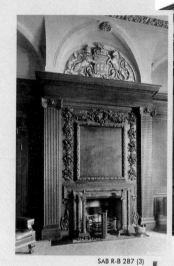

SAB R-B 287 (3)

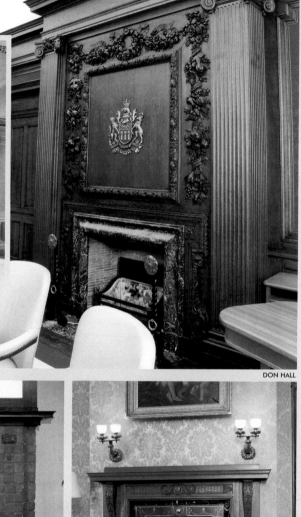

DON HALL

DON HALL

SAB 87-1704-19

SAB 87-1704-09

Keeping Time...

In 1979, government workers were surprised to find an oak grandfather clock case stored in a dusty government warehouse (below; detail, centre). The case, approximately six feet high, was intricately carved, with clawed feet and a small beaver—symbolic of the importance of the fur trade in the early development of western Canada—perched on top. Rather than the usual glass door in front of the pendulum and weights, the front of this clock had a solid oak door.

A careful search of records at the Saskatchewan Archives Board revealed that, on June 20, 1912, S.H. Carpenter, Acting Deputy Minister of Public Works, placed an order with the Bromsgrove Guild of Montreal for furniture for the Cabinet Chamber; included in this order was an oak clock case. The case had been designed by the Maxwell brothers and was carved by the Bromsgrove Guild at a cost of $200.

Carpenter ordered a clock case—rather than a complete clock—for a reason. The Scott government was particularly proud of the fact that the new Legislative Building was electrified, and Walter Scott in particular was eager to incorporate the latest modern conveniences into the building whenever possible. As such, it was decided to have electric clocks installed throughout the building, including the grandfather clock. This fact, in turn, explains why the case had a wooden door on the front—there never had been a pendulum or weights inside. The electric clock was purchased

DON HALL

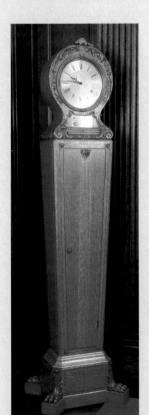

DON HALL

from Henry Birks and Sons Ltd. of Montreal and cost $50—a significant expense at the time. By having the electrical clock housed in a specially designed oak case, the planners were able to achieve a fitting combination of tradition and modern technology.

The grandfather clock was placed in the Cabinet Chamber in October 1913 and continued in use until the mid-1950s. It was probably removed from the Cabinet Chamber and placed in storage when the electrical workings wore out. After it was rediscovered in 1979, the case was restored and a new pendulum clock and face were installed. The refurbished clock was returned to its original spot in the Cabinet Chamber in January 1980.

The clocks in the main hallways of the building are beautiful timepieces, full of symbolism (right). The black, wrought-iron cases surrounding them are engraved with the letters "GR"—for *Georgius Rex*. Throughout the building, one can see "GR" and "ER"—for the two monarchs who reigned during the construction of the building, Edward VII (1901-1910) and George V (1910-1936). Although beautiful, however, the clocks apparently did not run "like clockwork," as the Deputy Minister of Municipal Affairs noted when he wrote to the acting Deputy Minister of Public Works shortly after the official opening of the building: "We will make no comment on the wonderful clocks which ornament certain portions of the Department but which were evidently never intended to give any reliable information regarding time."

DON HALL

67

The Legislative Library

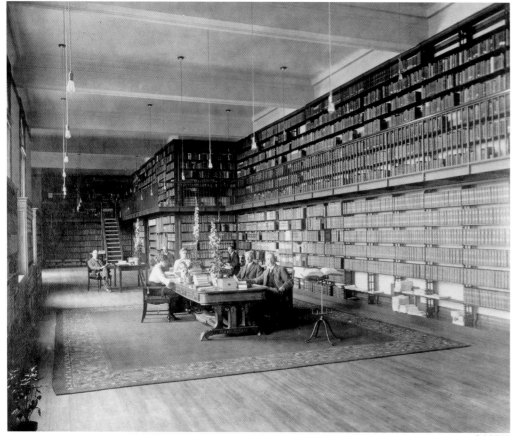

SAB R-B 18

THE LEGISLATIVE LIBRARY: The stack room in its early years was sparsely furnished, but well-stocked with books and research material. The stack room today, shown on facing page, is equipped with computers, card files, and additional shelving. John Hawkes, the first Saskatchewan Legislative Librarian (shown on facing page), believed that libraries were for serious researchers, and were not to be places for fun or frivolity. A sign prominently displayed in the library read: "Loud talking in the library is strictly against rules."

The Legislative Library is located on the second floor (north side) of the East wing. The Maxwell brothers purposefully placed the library on the North side to reduce the intensity of the sunlight reflected off the winter snow. Entering the reading room is like stepping back in time. There, visitors can see portraits of all the former Premiers, three official chairs which were used by various Speakers of the Legislature, Walter Scott's office desk and his desk from the Legislative Chamber, and the Confederation Table.

The Library is a quiet hideaway where readers can peruse a wide selection of print material including local, provincial, and national newspapers. To date, the Legislative Library collection contains nearly half a million titles, one-third of which are stored on site, with the remainder in closed stacks in a building nearby.

This superb collection of print and video material on Saskatchewan and Canadian politics, history, and public policy had surprisingly humble beginnings. In 1876, when Lieutenant Governor David Laird arrived at Fort Livingstone in the North-West Territories, he brought with him his personal collection of books, law texts, and public documents. He generously bequeathed these to the Territorial Assembly at the end of his term.

The collection followed the Territorial Assembly, first to Battleford and, by 1883, to Regina; it was recognized as a library by the mid-1880s. The library was moved from one site to another within Regina until it settled into its permanent home in the new (and still incomplete) Legislative Building in 1910. In January 1911, the Legislative Assembly held its session in the reading room of the Legislative Library because the Chamber had not yet been completed.

The earliest library staff and patrons had to contend not only with the noise and dust of the construction phase of the building, but also with the effects of the cyclone of June 30, 1912, which caused its greatest damage to the section of the Legislative Building which housed the library. The windows and walls in the library were damaged, with books and papers strewn on the floor. However, life in the library soon returned to normal.

Throughout its history, the Legislative Library has been led by several patrons. Originally the library was managed by the Lieutenant Governor himself. By 1893, the library was under the leadership of a librarian who reported to the Executive. When the province was created in 1905, the Legislative Library became officially known as the Saskatchewan Legislative Library. The library was under the supervision of the Speaker during the session and was under the supervision of the Premier between sessions. It was not until 1980–81 that the library was placed under the year-round authority of the Speaker.

Ever-expanding, the Legislative Library continues to be a showpiece for Saskatchewan's heritage, and is arguably the best location anywhere to conduct research on Saskatchewan politics, history, and public policy. In keeping with the times, the library now houses a collection of computers for website searches. A well-trained and professional team of librarians and staff serve members and visitors in the proud tradition of David Laird and John Hawkes. Anyone with a research question and a love of learning is made most welcome in this, the oldest library in the province.

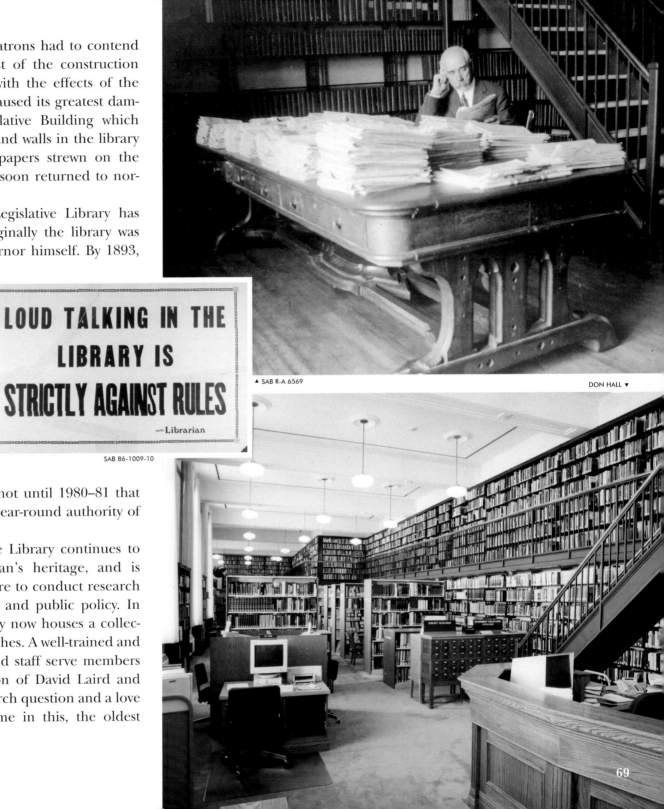

LOUD TALKING IN THE LIBRARY IS STRICTLY AGAINST RULES

—Librarian

SAB 86-1009-10

▲ SAB R-A 6569

DON HALL ▼

DON HALL

SASKATCHEWAN LEGISLATIVE BUILDING ART COLLECTION

THE CONFEDERATION TABLE: Not all of the furniture in the Legislative Building was new when it opened in 1912. When the Legislative Assembly moved into the Chamber in January 1912, the "so-called" Confederation Table— believed to have been used at the Quebec Conference in 1864—was situated in the centre of the room and used by the Clerk. (Known for certain is that the table was used by the Privy Council in Ottawa in 1865.) Given to the North-West Territorial Council by the government of Canada, it had been moved from one Council room to another until it finally came to the Chamber in the new building, pending arrival of the new table which was being built. After its replacement, the Confederation Table was used in the Legislative Library. Ultimately, it became a display in the reading room, where it can be seen today (above). The table is shorter today than it was when it first arrived in the West. When the Assembly moved from the Government buildings on Dewdney Avenue to the Post Office on 11th Avenue, the table was found to be too long for its new, but temporary, quarters: a six-foot section was cut from the middle of the table and the two end pieces reattached. The carpenter's affadavit (right) explains the details of the episode and the fate of the middle section.

70

CONFEDERATION TABLE.

I hereby state that I am the party who shortened the length of the Old Confederation Table (now in the Legislative Library), by 6 feet, at the Old Legislative Buildings, Dewdney avenue, under the instructions of the late F.J.Robinson, the Deputy Minister of Public Works, so that it might be made possible to convey it to the top of the new Post Office, to where the Session of 1908 was adjourned.; and I further state, that the portion cut out, was not made into a Souvenir Table, but was used up as repairs - for other work.

SAB 86-1009-12

OVER THE MANTLE of the fireplace in the reading room hangs the painting *Bisons in a Storm* by Frederick Arthur Verner (above). Both beautiful and mesmerizing, the work is one of the more than two hundred pieces in the Legislative Building Art Collection. Also among the artworks and artifacts in the Legislative Library is a desk and chair used by Saskatchewan's first premier, Walter Scott (below).

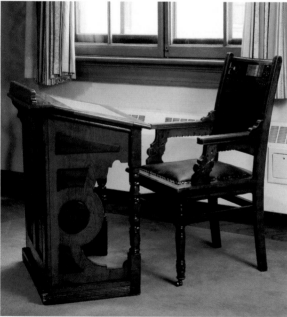

DON HALL

Legislative Librarians	
John Hawkes	1907–1927
William F. Kerr	1927–1930
J.W. Reid	1930–1932
Jessie Bothwell	1932–1934
Samuel J. Latta	1934–1944
Jessie Bothwell	1944–1951
John H. Archer	1951–1964
Allan R. Turner (Acting)	1964–1966
Leonard Gottselig	1966–1971
Christine MacDonald (Acting)	1971–1973
Christine MacDonald	1973–1982
Marian J. Powell	1982–present

SAB 59-063-04

CIRCA 1959: Patrons and staff read and research in the stack room (above) and the reading room (below). The Legislative Library maintains basic reference works on many subjects, as well as materials in the areas of law, economics, parliamentary matters, political science, sociology, and western Canadian history. While the Library may have had humble beginnings, its collection has grown to become the third largest in the province, housing approximately one-half million bound volumes of books, government publications, periodicals, and microforms.

SAB R-A 10210 (1)

SERGEANT BILL: One of the more peculiar oddities to inhabit the Legislative Library was a stuffed goat. When he was alive, "Sergeant Bill" (above) had been the mascot of the Fifth Canadian Battalion in France from 1915 to 1918. The goat, who had been gassed, wounded, and decorated, eventually returned safely to Canada, finishing his years out to pasture in his original hometown, Broadview. Destined for display in the province's proposed War Memorial Museum, the "sergeant" wound up residing briefly in the reading room of the Legislative Building in the 1920s, where he became a designated meeting place. Sergeant Bill was eventually returned to Broadview, where he is now honoured in the Broadview Museum.

SAB 59-063-02

Secret Staircase?

There are persistent—albeit unconfirmed—stories that the Legislative Building contains a secret stairwell from the second-floor Library to the basement. This stairwell, so the stories go, allowed MLAs to appear to be going to the Library for research, while in reality they were stealing away to a room in the basement to play cards and drink alcohol (which, of course, was forbidden during the prohibition years). Such unedifying behaviour would have been viewed with disapproval by the majority of the voting public.

71

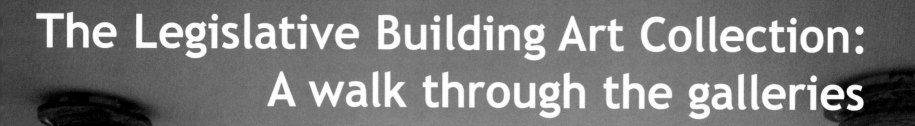

The Legislative Building Art Collection:
A walk through the galleries

Ｔhe Legislative Building Art Collection was envisioned even before the building was completed. In 1910, Premier Scott commissioned the painter Edmund Morris to create a series of portraits of Plains Indian leaders for the new building. Over the years, the collection has grown and today consists of approximately two hundred pieces. The Provincial Secretary of Saskatchewan oversees the collection, a responsibility that includes the commissioning of new artwork, the restoration and conservation of the collection, and researching and maintaining documentation and historical records.

In the collection are portraits of monarchs and of the province's Lieutenant Governors, Premiers, and Speakers, sculptures, prints, lithographs, and photographs—including composites documenting Saskatchewan's Legislatures, depicting all elected members, Speakers, the Clerks and their staff. Throughout the building can be found masterpieces, such as Verner's *Bisons in a Storm*, and historically invaluable works, such as the Richard Lindemere paintings recording the first years of the North-West Mounted Police.

While the Legislative Building Art Collection is by far the largest collection in the building, the works displayed in the Cumberland Gallery are no less significant. Operated under the auspices of the Saskatchewan Property Management Corporation, the gallery, which was officially opened by Prince Charles in April 2001, features First Nations artists and travelling exhibits. The Athabasca Gallery on the second floor of the Legislative Building contains photographic portraits of recipients of the Saskatchewan Order of Merit.

The following pages provide but a glimpse into the vast collection of artworks housed within the building.

Assiniboine Gallery:
The Edmund Morris Paintings

EDMUND MORRIS was born in 1871 in Perth, Ontario. He was the son of Alexander Morris, Lieutenant Governor of Manitoba and the North-West Territories from 1872–1876. Morris studied art in New York and Paris, returning to Canada to found the Canadian Art Club in 1907. During his lifetime, Morris was primarily known as an "Indian" portraitist—today, his bold use of colour and expressive brushwork are recognized as greatly contributing towards modernist Canadian painting in the early twentieth century. Fifteen pastel portraits by Edmund Morris are featured in the Legislative Building's Assiniboine Gallery (a selection is shown here). Chief Roland Crowe of the Federation of Saskatchewan Indian Nations and former premier Roy Romanow officially opened the renovated gallery in 1991.

ALL PHOTOS THIS PAGE COURTESY OF THE
SASKATCHEWAN LEGISLATIVE BUILDING ART COLLECTION

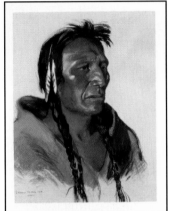

Gambler – Ometaway

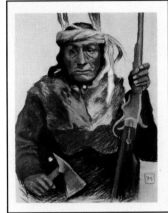

Chief Big Bear –
Mis-Taha-Mus-Qua

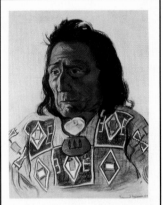

Moses

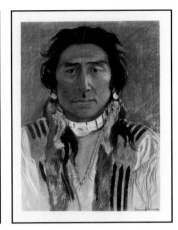

Chief Carry the Kettle Chagakin

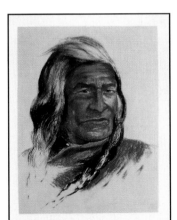

Chief Piapot

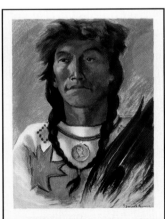

Walter Ochopowace

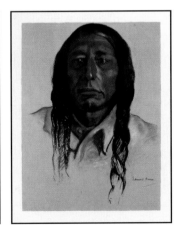

Chief Poundmaker –
Pee-Too-Kah-Han

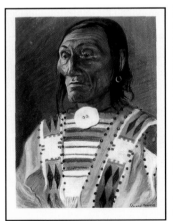

Pahnap "Medicine Man"

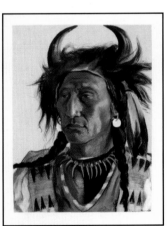

Big Darkness

Qu'Appelle Gallery: Lieutenant Governors since 1905

Since the formation of Saskatchewan in 1905, various governments have commissioned nationally and internationally renowned artists to paint the portraits of the province's Lieutenant Governors. Protocol dictates that a period of time passes before a portrait is hung in the gallery—thus, the paintings of Lieutenant Governors Jack Wiebe and Lynda Haverstock are yet to be unveiled.

ALL PHOTOS THIS PAGE AND FACING PAGE COURTESY OF THE SASKATCHEWAN LEGISLATIVE BUILDING ART COLLECTION

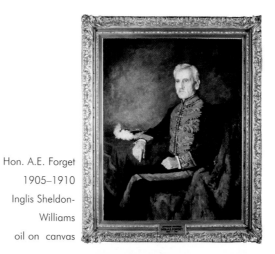

Hon. A.E. Forget
1905–1910
Inglis Sheldon-Williams
oil on canvas

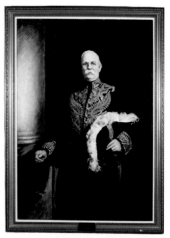

Hon. G.W. Brown
1910–1915
Hubert Von Herkomer
oil on linen

Hon. R.S. Lake
1915–1921
Philip De Laszlo
oil on canvas

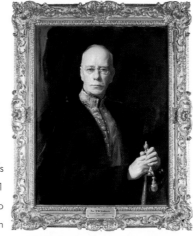

Hon. H.W. Newlands
1921–1931
Philip De Laszlo
oil on linen

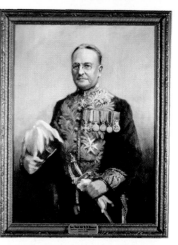

Hon. H.E. Monroe
1931–1936
Augustus Kenderdine
oil on linen

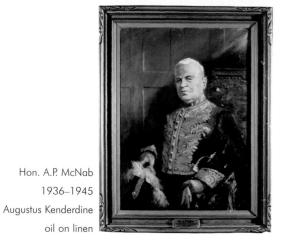

Hon. A.P. McNab
1936–1945
Augustus Kenderdine
oil on linen

Hon. T. Miller
1945
John S. Perry
oil on canvas

Hon. R.J.M. Parker
1945–1948
John S. Perry
oil on linen

Hon. J.M. Uhrich
1948–1951
Nicholas De Grandmaison
pastel on pastel paper

Hon. W.J. Patterson
1951–1958
John Martin Alfsen
oil on canvas

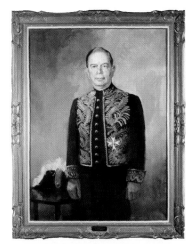

Hon. F.L. Bastedo
1958–1963
Elizabeth R.
Goward
oil on linen

Hon. R.L. Hanbidge
1963–1970
S. Paul Cloutier
oil on linen

Hon. S. Worobetz
1970–1976
William Tkach
oil on linen

Hon. G. Porteous
1976–1978
Cyril G. Leeper
oil on linen

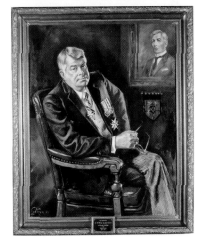

Hon. C.I. McIntosh
1978–1983
Cyril G. Leeper
oil on linen

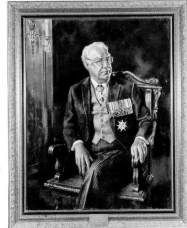

Hon. F.W. Johnson
1983–1988
Cyril G. Leeper
oil on linen

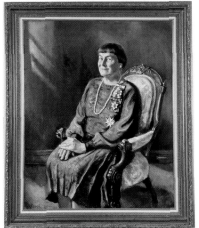

Hon. S.O.
Fedoruk
1988–1994
Cyril G. Leeper
oil on linen

Saskatchewan Gallery: Premiers

The Saskatchewan Gallery honours the Premiers of Saskatchewan, as well as the Honourable F.W.G. Haultain, Premier of the North-West Territories from 1897 to 1905. Both the Qu'Appelle and Saskatchewan galleries were designed by Regina architect Clifford Wiens. The portraits of Premiers Grant Devine and Roy Romanow are yet to be unveiled. The portrait of Premier Lorne Calvert is in progress.

ALL PHOTOS THIS PAGE AND FACING PAGE COURTESY OF THE SASKATCHEWAN LEGISLATIVE BUILDING ART COLLECTION

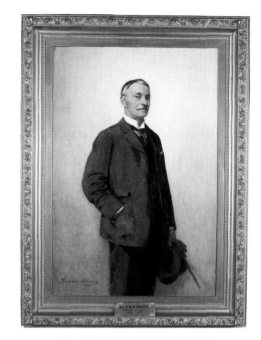

Hon. F.W.G. Haultain, 1897–1905

Inglis Sheldon-Williams, oil on canvas

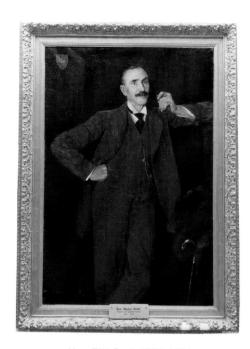

Hon. T.W. Scott, 1905–1916

Inglis Sheldon-Williams, oil on canvas

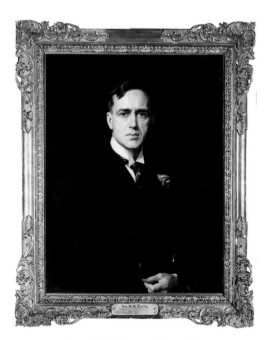

Hon. W.M. Martin, 1916–1922

Philip De Laszlo, oil on linen

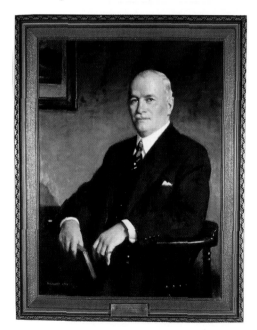

Hon. C.A. Dunning, 1922–1926

Richard Jack, oil on canvas

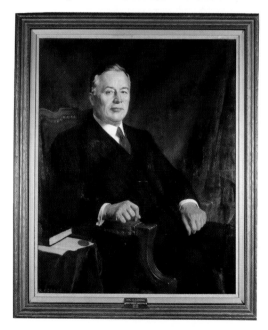

Hon. J.G. Gardiner, 1926–1929, 1934–1935

K. Forbes, oil on linen

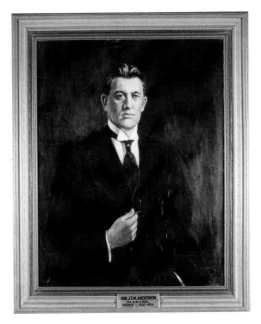

Hon. J.T.M. Anderson, 1929–1934

John S. Perry, oil on linen

Hon. W.J. Patterson, 1935–1944

Nicolas De Grandmaison, pastel on pastel paper

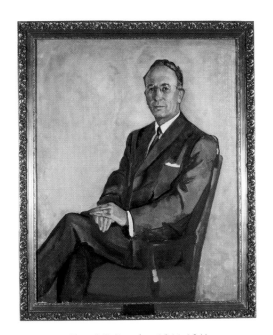

Hon. T.C. Douglas, 1944–1961

Lilias Torrance Newton, oil on canvas

Hon. W.S. Lloyd, 1961–1964

William Tkach, oil on linen

Hon. W.R. Thatcher, 1964–1971

S. Paul Cloutier, oil on canvas

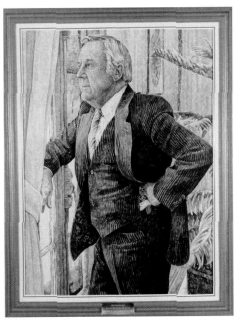

Hon. A.E. Blakeney, 1971–1982

Wilfred Donat Perreault, acrylic on canvas

The Speaker's Gallery

Speakers of the Territorial Legislative Assembly

Hon. H.C. Wilson	1888–1891
Hon. J.H. Ross	1891–1894
Hon. J.F. Betts	1895–1898
Hon. W. Eakin	1899–1902
Hon. A.B. Gillis	1903–1905

Speakers of the Provincial Legislative Assembly

Hon. T. MacNutt	1906–1908
Hon. W.C. Sutherland	1908–1912
Hon. J.A. Sheppard	1912–1916
Hon. R.M. Mitchell	1917–1919
Hon. G.A. Scott	1919–1925
Hon. W.G. Robinson	1925–1929
Hon. J.F. Bryant	1929–1929

After 1930, photographed, rather than painted, portraits recognize the Speakers of the Legislative Assembly:

Hon. R.S. Leslie	1930–1934
Hon. J.M. Parker	1934–1938
Hon. C. Agar	1939–1944
Hon. T. Johnston	1944–1956
Hon. J.A. Darling	1957–1960
Hon. E.I. Wood	1961–1961
Hon. F.A. Dewhurst	1962–1964
	1971–1975
Hon. J.E.P. Snedker	1965–1971
Hon. J.E. Brockelbank	1975–1982
Hon. H.J. Swan	1982–1986
Hon. A.B. Tusa	1986–1991
Hon. H.H. Rolfes	1991–1996
Hon. G.J. Hagel	1996–1999
Hon. R. Osika	1999–2001
Hon. M. Kowalsky	2001–present

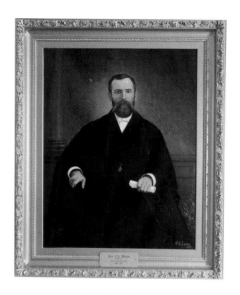

Hon. H.C. Wilson

V.A. Long, oil on linen

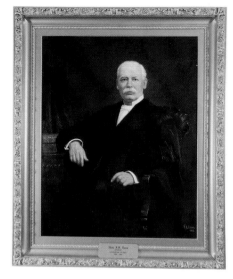

Hon. J.H. Ross

V.A. Long, oil on linen

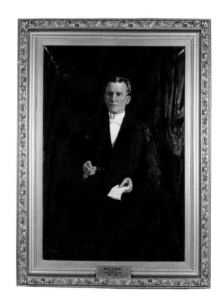

Hon. J.F. Betts

V.A. Long, oil on linen

Hon. W. Eakin

V.A. Long, oil on linen

ALL PHOTOS THIS PAGE AND FACING PAGE COURTESY OF THE SASKATCHEWAN LEGISLATIVE BUILDING ART COLLECTION

Hon. A.B. Gillis

V.A. Long, oil on linen

Hon. T. MacNutt

V.A. Long, oil on linen

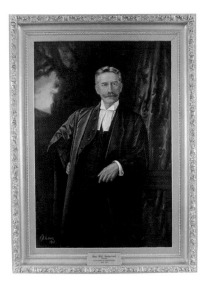

Hon. W.C. Sutherland

V.A. Long, oil on linen

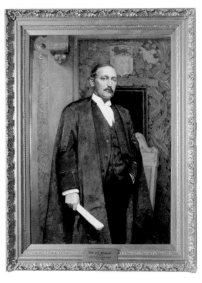

Hon. J.A. Sheppard

Inglis Sheldon-Williams, oil on linen

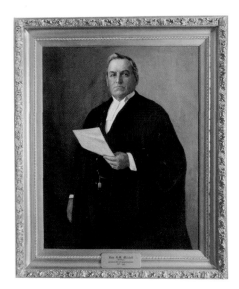

Hon. R.M. Mitchell

James Henderson, oil on linen

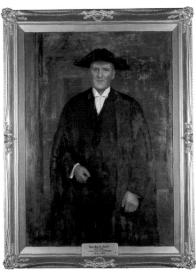

Hon. G.A. Scott

C.S.R. Ferguson, oil on linen

Hon. W.G. Robinson

Richard Lindemere, oil on canvas

Hon. J.F. Bryant

John D. Leman, oil on linen

From Many Peoples Strength

Most public buildings are more than the sum of their parts and Saskatchewan's Legislative Building is no exception. It has become significant not only for its function as the house of the provincial government, not only for the momentous historic events and speeches that have occurred under its lofty dome or upon its majestic grounds, not only for its architectural beauty—what makes, and has always made, the building truly significant is *people*.

Thousands of Saskatchewan people have worked in the building over the years—legislators, of course, but also accountants, cooks, tour guides, and custodial staff. Thousands more have come to the building to be recognized for some special achievement, to be honoured for their contribution to society, or to become Canadian citizens. Thousands have attended ceremonies, meetings, luncheons, conferences, and receptions held in the building. The Legislative Building has been, and remains, the place where the people of Saskatchewan and their government become one.

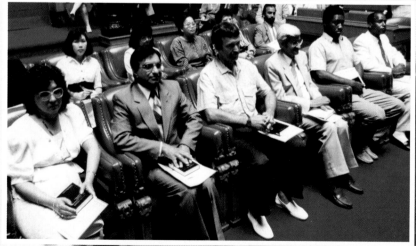

"*Multis E Gentibus Vires*" (From Many Peoples Strength) is the province's motto and appears on the coat of arms. It expresses the ethnic and cultural diversity of Saskatchewan's population. Each year, approximately 1000 people become new Canadians in citizenship ceremonies in the province. Traditionally, an annual investiture has taken place at the provincial legislature on July 1, Canada Day. Above, seated in the public gallery in the Legislative Chamber are new Canadians attending the official opening of the legislature, February 1959. Thirty years later, a swearing-in ceremony (left) in the Legislative Chamber, July 1, 1989.

SAB 89-0682-R1-18A

SAB 58-674-07

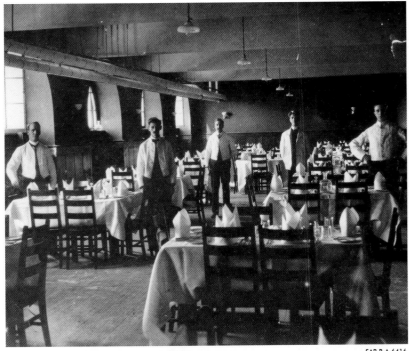

SAB R-A 6416

SAB 59-620-01

AT WORK: (clockwise from top left) Waiters in the dining room have the table set for dinner circa 1915; Frank Klyberg spins vinyl in the Travel and Information radio room in the Legislative Building in 1959; the office of the provincial architect, L.A. Gallus, was located in the building in 1961—Mr. E. Dauenhauer was the draftsman; Jean Turner (left) and Jeanette Savage (right) work in the mailing room of the School Broadcasts and Music Education Branches, Department of Education.

SAB 57-006-01

SAB R-B 5604

SAB 59-634-01

WORKING THERE: When the Saskatchewan Legislative Building first opened in 1912 and for the next half-century, the offices of the ministers and most departments were scattered throughout. In November 1959, the Department of Public Works was located in Room 138 (above). The 1954 photo below shows the newly renovated offices of the Provincial Treasury Department. By the 1970s, however, line departments had been moved out of the Legislative Building, thereby allowing more space for cabinet ministers, their private staff, and MLAs from all parties. The West wing now houses government MLAs, while offices in the East wing are for members of the Opposition.

GET TOGETHERS: The Department of Highways Engineers Conference was held in Room 267 in January 1952 (top right); In 1954, the Municipal Affairs Branch held a banquet in the Dome Café (centre right); and the Saskatchewan Poultry Board met (bottom right) in the former members' smoking lounge, May 26, 1943. (The tile fireplace in the background was sometime thereafter enclosed within a wall, only to be rediscovered during renovations to the building in the 1980s.)

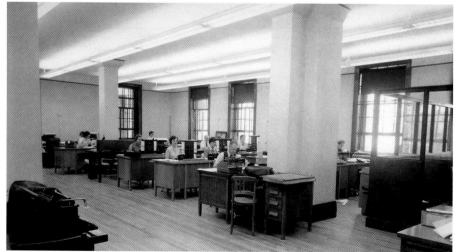

SAB R-B 6289 (1)

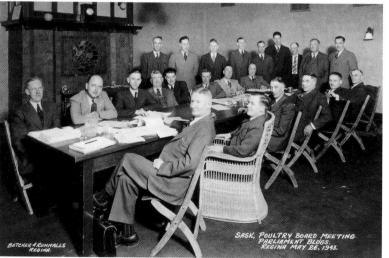

SAB R-B 6476

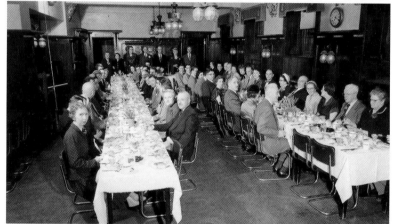

SAB R-B 6695

SASK. POULTRY BOARD MEETING
PARLIAMENT BLDGS.
REGINA MAY 26, 1943.

BUTCHER & RUNNALLS
REGINA.

SAB R-D 1952

SAB 56-455-01

SAB 79-2740-06

SAB 62-953-09

MEET THE PRESS: An informed public is essential to democracy—vital to holding our elected representatives accountable. Broadcasts to the public often emanated from the Radio Room (top left), which was located on the third floor of the Legislative Building. Pictured here in December 1956 are, from left to right, Hon. R. Brown, Provincial Secretary, Hon. J.H. Brockelbank, Minister of Mineral Resources, Hon. T.C. Douglas, Premier, D.H.F. Black, Director of the Industrial Development Office, and D. Cass-Beggs, General Manager of Saskatchewan Power. Reporters typed up their stories in the Press Room of the Legislative Building following the daily session of the Legislature (the photo left was taken in March 1963). Perhaps a future member of the press (above), this intrepid young reporter (a grade-school student) put the tough questions to Premier Blakeney in March 1980.

SAB 55-434-02

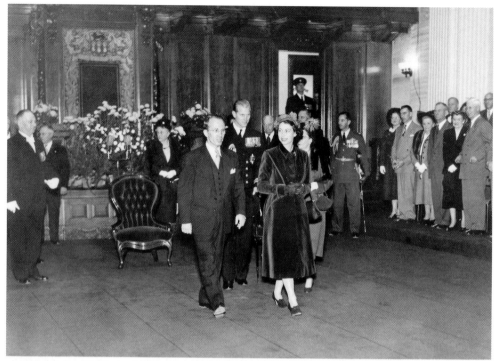

SAB R-A 5359 (1)

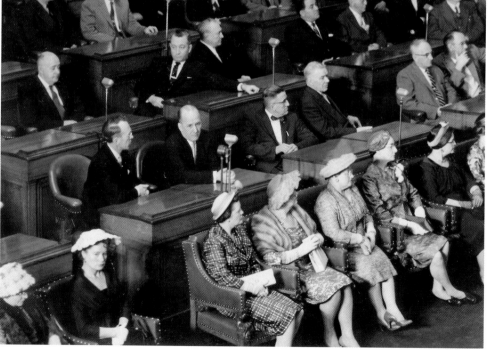

CEREMONIES of all kinds are held in the Legislative Building. Two veterans (above) placed a memorial wreath on November 11, 1955. Each year, those who served our country in war and paid the ultimate price are remembered through solemn ceremonies such as this at the Legislative Building.

Presiding over official ceremonies is the job of every Premier—but every so often the occasion is just a bit more "special"—as when Premier Douglas (top right) played host to Princess Elizabeth at a reception in the Legislative Assembly Chamber in 1951.

More ceremony opens every new session of the legislature. Additional seating is brought into the Chamber and special guests are in attendance—as they were at the opening of the 3rd Session of the 13th Legislature (right) in February 1959. A 19-gun salute is fired as the Lieutenant Governor arrives in the horse-drawn landau to deliver the Speech from the Throne.

84

SAB 58-686-01

SAB 59-952-02

SAB 74-284-13

SAB 60-989-02

PRESENTATIONS AND HONOURS: The Legislative Building is often the venue for special presentations to accomplished Saskatchewan citizens, as it was for the athletes pictured here. In March 1960, the world's curling champions—the Curling Richardsons from Stoughton, Saskatchewan—were honoured at the Legislative Building on behalf of the people of Saskatchewan (top left). From left to right are Sam, Wes, Arnold, and Ernie Richardson, together with their proud grandmother, Anne Richardson. More curlers, this time representing the Hub City Curling Club in Saskatoon, were honoured in the Saskatchewan Legislature in March 1961 for achieving Canadian ladies' curling supremacy (left). The rink received engraved silver trays from the province in recognition of their accomplishment. Standing left to right are Premier Douglas, Joyce McKee, Sylvia Fedoruk (a future Lieutenant Governor of the province), House Speaker Wood, Barbara MacNevin, Rosa McFee, and Opposition Leader Ross Thatcher. Another athlete, another presentation (above): Hon. John Kowalchuk (left) presented the first 1974 parks sticker to Dennis Sobchuk (second from right) of the Regina Pats hockey team.

85

Beyond the Building

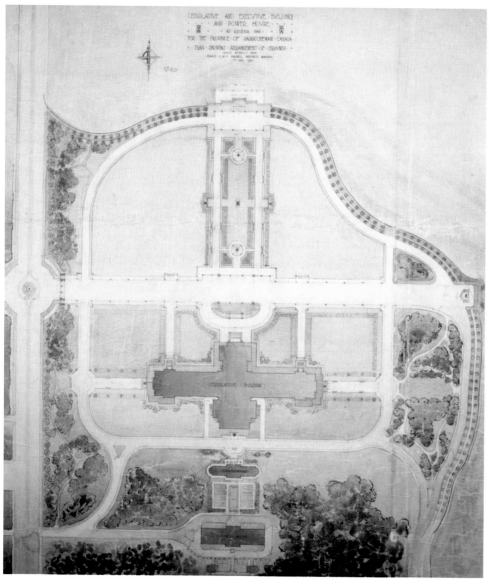

SAB MAP B620.12

Visitors to the Saskatchewan Legislative Building frequently comment on the beauty of the park in which it is situated, and were it not for archival photographs, it would be difficult to imagine how much the area has changed in the last century and a half. When explorer Captain John Palliser first visited the site in 1857 he recorded, "Our course was due west, and as far as the eye can reach nothing but desolate plains meet the view: at noon reached a small creek called 'The Creek Before Where The Bones Lie,' here we found water and some little grass, also a few willow and cherry bushes, but no wood for fuel." Mistaking the aboriginal name (Oskana) for this site, Palliser called it Wascana.

Sir John A. Macdonald, Canada's first Prime Minister, was hard-pressed to be tactful when asked his opinion of what is now Regina: "It would be improved by a little more wood, and a little more water, and here and there a hill." There are still no hills to be found in or around Regina, but the legislative grounds, at least, have considerably more wood and water than was the case in Sir John's day, and this, yet again, is due to the foresight of Walter Scott and his government.

Determined that the legislative grounds should reflect the grandeur of the building itself, the government hired landscape architect Frederick G. Todd to prepare an initial design. Todd's plan arranged for the building to face north across the reservoir on Wascana Creek, on an axis in line with Smith Street. It was to be situated on a high point of land, surrounded by greenery.

LANDSCAPING PLANS: This watercolour by Edward and W.S. Maxwell shows the immediate vicinity of the Legislative Building. To the south (toward the bottom of the picture) are seen the conservatory (demolished), the powerhouse, and the two caretaker's cabins (also demolished).

Todd planned to have hardy indigenous trees—which could withstand the harsh prairie winters—intermingled with more exotic species to provide variety. To this end, some 100,000 trees and shrubs were planted between 1908 and 1912. Greenhouses were built on the grounds so that trees could be raised from seed, and in the spring of 1913 alone, 11,000 seedlings were planted, from over 100 varieties of trees and shrubs.

However, as time went by, problems arose with Todd's design. A native of Montreal, he had not anticipated the harshness of the winter and the wind on the prairie landscape, and many of the varieties of trees and shrubs he had selected died, while the hedges planted close to the sidewalks became traps for the drifting snow. To rectify the problems, Thomas Henry Mawson, a well-known urban planner from the "City Beautiful" school, was invited in 1912 to undertake three urban projects: a landscaping plan for the city of Regina; further designs for the grounds around the Legislative Building; and the selection of a location, accompanied by a landscape plan, for a new Government House.

SAB R-A 7499 (1) SAB R-A 17162 (2)

EVEN AS THE FOUNDATIONS were being laid, work around the building was underway. George Watt, originally the head gardener at Government House (seen above left in the conservatory circa 1905), was hired in 1908 to become Regina's city gardener and was responsible for planting the first elm trees and carragana bushes in the city. He soon resigned, however, when asked by the provincial government to work on the Legislative Grounds. In 1912, Watt would face the heartbreak of seeing years of work undone as approximately 20,000 young trees were uprooted by the "Regina Cyclone." The photograph below shows Wascana Park four months later, at the time of the Legislative Building's official opening. In 1921, Watt again accepted another position, becoming the province's landscape architect. Continuing the work on the Legislative Grounds was Mr. Zurowski—seen above right planting trees in the park in 1927.

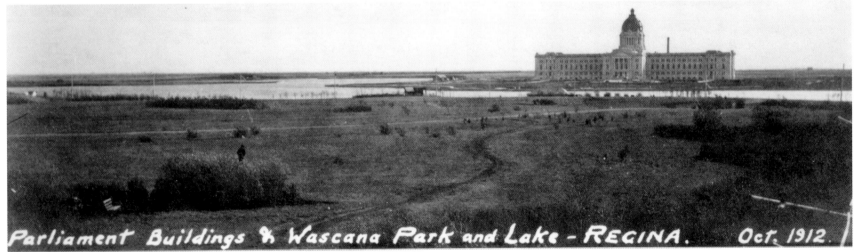

SAB R-A 24072 (2)

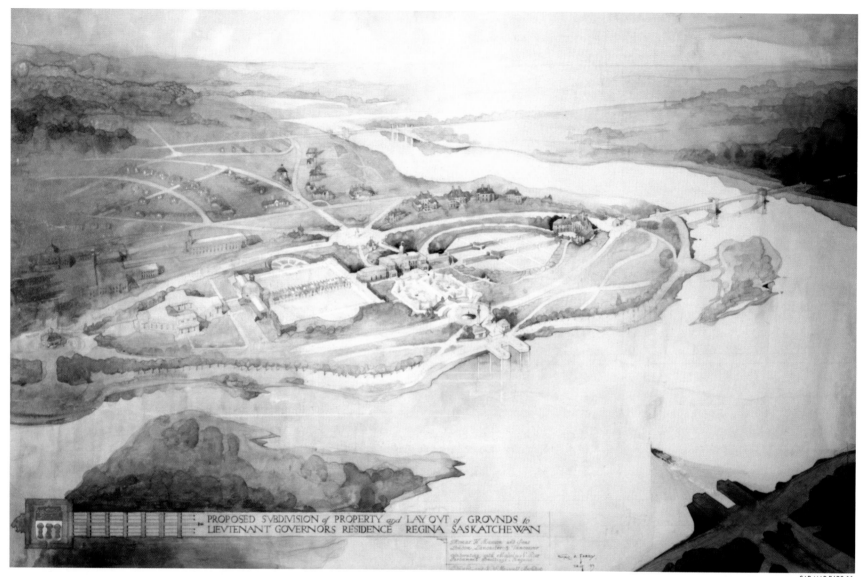

SAB MAP B620.11

PROPOSED SVBDIVISION of PROPERTY and LAY OVT of GROVNDS to
LIEVTENANT GOVERNORS RESIDENCE REGINA SASKATCHEWAN

THE "MAWSON PLAN" (facing page), as it came to be called, integrated the Legislative Building, the lake, and the landscaping. Mawson laid out large flower beds in front of the building, with straight walks and hedges, and symmetrical gardens to the east and west of the building.

Mawson also proposed that the new Government House be located across the lake to the east of the Legislative Building. His design (above) included special piers at both the Legislative Building and Government House so that the Lieutenant Governor could travel by royal barge from his residence to the Legislature for the opening of a new session. (Little did Mawson realize that the Legislature usually began its annual session in February, when boats were not navigating Wascana Lake!) The "Mawson Plan" was well received, but, due to the outbreak of World War I, only the landscaping plans for the legislative grounds were implemented.

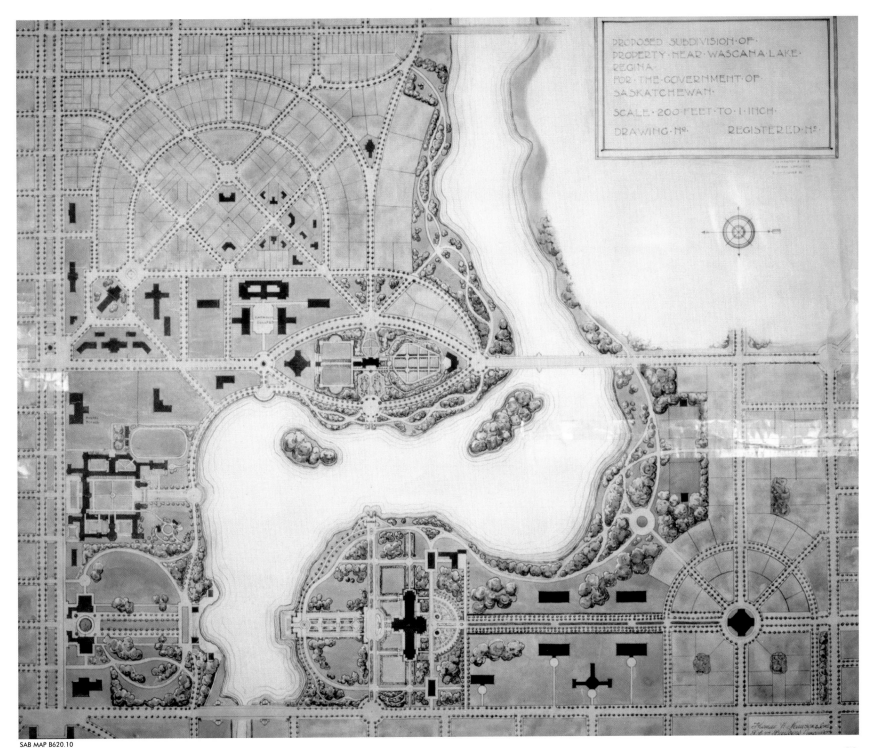

PROPOSED SUBDIVISION OF
PROPERTY NEAR WASCANA LAKE
REGINA
FOR THE GOVERNMENT OF
SASKATCHEWAN

SCALE 200 FEET TO 1 INCH

DRAWING Nº REGISTERED Nº

SAB MAP B620.10

89

SAB R-B 3713

"Wascana creek area was indeed crowded with work-men during 1908. Crews working on the two bridges, men with horses and scrapers deepening the lake bed while others were building the retaining wall and steps. South of this area, men and teams were excavating for the Legislative building which was started that year."

—Marguerite E. Robinson

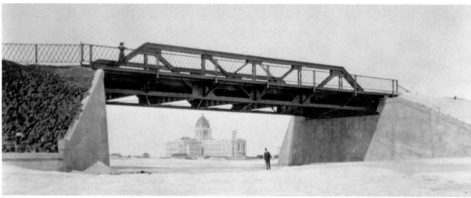

SAB R-A 24069

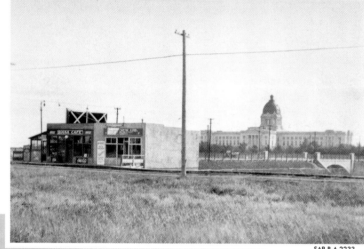

SAB R-A 2233

SAB R-A 2302

THE WISDOM OF WALTER SCOTT was questioned by many in 1906 who disagreed with his government's decision to place the Legislative Building on the side of the creek opposite the city. Just how isolated the new building was is evident in the photo (bottom) on the facing page. The owners of a Rumely Oilpull tractor draw harrow over plowed virgin prairie, three miles south of downtown Regina, circa 1913—the newly completed Legislative Building is just visible in the background. Yet, since 1906, many generations have enjoyed and benefited from Scott's decision to surround the Legislative Building with a large park. In many other provincial capitals, the city has been allowed to closely surround the Legislative Building; Scott's planning ensured that the Legislative Building in Saskatchewan would be distinctive, not cramped by the city but on its own in a park with trees, grass, birds, and flowers. He withstood the pressures of his day in order to fulfill his vision.

The provincial government awarded Parsons Construction Company the contract to build the first Albert Street Bridge in 1908 (facing page, top left). It was a reinforced concrete arch spanning 80 feet replacing the old wooden dam further west. By the 1920s, businesses had located at the bridge's north end (facing page, inset right). The old Broad Street Bridge (facing page, middle left), begun the same year as the Albert Street Bridge, was completed in 1909. After beginning to show signs of structural defects in the early 1950s, the old bridge was finally demolished in 1960. The lake was then widened, and a new bridge was built about a thousand yards further east. The south abutment of the old Broad Street Bridge still remains, and is today a scenic lookout.

By 1910, picnics in the park were becoming popular (top right), and as J.A. Calder had correctly predicted when selecting the site for the Legislative Building, the area would soon see streetcar service. The inaugural streetcar run was on July 28, 1911—with free rides provided for the day. (The photo below was taken circa 1915–19.) In 1925, visitors to the capital had the option of camping at the Tourist Auto Camp (below, right) on the shores of Wascana Lake (roughly in the area of the Willow Island ferry dock today). Initially, only tent camping was available, but in later years vacation cabins were built in the area of the camp office pictured. (The photograph has been digitally altered to repair damage to the original photo.) In the midst of the flat and dry prairie landscape, the park and lake were indeed becoming a sort of oasis. Taking respite from the heat on July 24, 1913, members of a travelling theatre group, who had been in Regina performing "Hanky Panky," put on an impromptu performance in Wascana Lake (middle right). The Regina Boat Club supplied the bathing costumes and canoes.

SAB R-B 1499

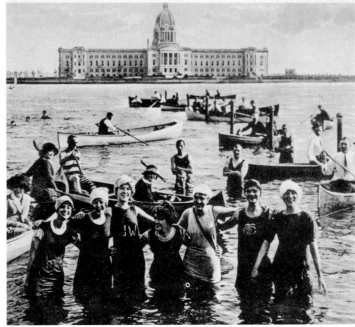

SAB R-B 674

SAB R-A 24067

SAB R-D 212

91

DEVELOPMENTS: As automobiles became increasingly popular, roadways were improved, the city expanded southwards, and the park became even more central to the lives of the people. Strolls or drives around the park became daily routine (the photograph below left was taken circa 1915). With the onset of the depression, and the drought of the 1930s, unemployment in Saskatchewan became the chief concern of government. Relief projects were undertaken, and all three levels of government—municipal, provincial, and federal—provided funding. Seven hundred men were employed to build the Albert Memorial Bridge (below right), and 2100 men, using only shovels and dump wagons, deepened the lake bed by two feet, creating Willow Island and Spruce Island from the excavated soil. (Interestingly, Thomas Mawson had proposed the islands nearly twenty years earlier.)

The park was not only increasingly an attraction during the summer months. In the winter, the more hardy would take to the ice, like these hockey players (right) on December 2, 1912, and these two ice-boaters (inset right) who braved the winter winds in the 1940s.

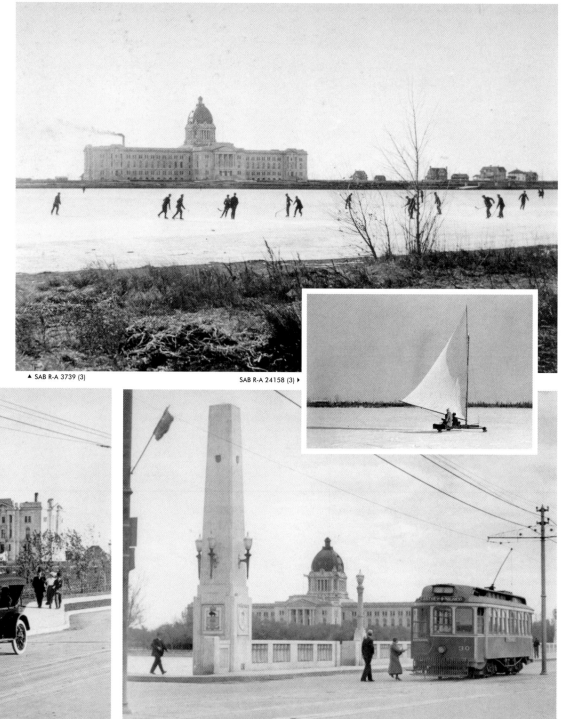

▲ SAB R-A 3739 (3)

SAB R-A 24158 (3) ▶

SAB R-B 1375 SAB R-B 3078

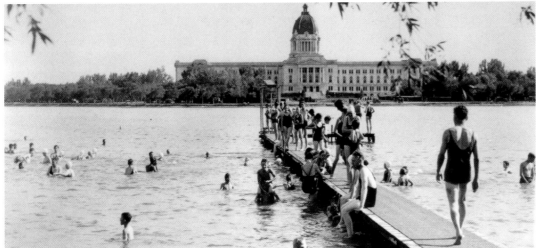

SAB R-A 15776

NATURE AND AN ARTIFICIAL LAKE: In the summer of 1882, the Canadian Pacific Railway built the first dam across Wascana Creek, creating a reservoir to provide water for its locomotives and to improve the fledgling town's water supply. The reservoir initially covered about 65 hectares and averaged about 1.5 metres in depth. It was also used for stock watering, and even attracted those adventurous enough to pursue recreational sailing. With new dams and dredging projects over the years, "Wascana Lake," as it came to be known, became popular for both boating and swimming. By the late 1920s, boat clubs and bathhouses lined the north shore of the lake (below). In the mid-1930s, swimmers still flocked to the docks and diving platforms (above left). In the 1940s, one could buy a five-cent ice-cream cone at O'Brien's Boathouse and tour Wascana Lake in the *Queen Mary*, a paddlewheeler which could accommodate up to 36 passengers (centre). However, by the 1950s (when this Trans Canadian Airlines flight passed over, above right), the lake had begun silting up with the passing seasons, becoming shallower; weeds and algae were beginning to make water sports, especially swimming, somewhat unpalatable. A half-century later, the idea of draining the lake and deepening the bottom continues to be debated. Without human intervention in the coming years, Wascana Lake will eventually naturalize, developing first into a marsh and then a meadow—a process already becoming visible east of the Broad Street Bridge.

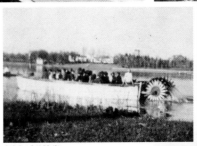

SAB R-A 24158 (2)

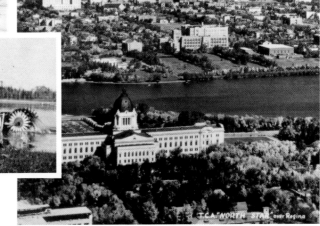

SAB R-B 9553

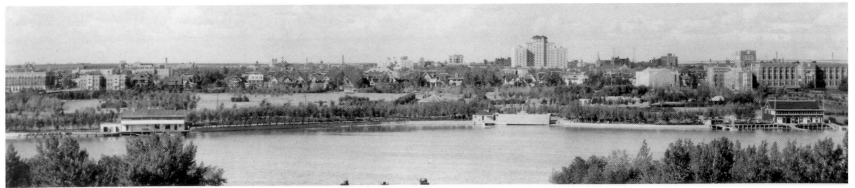

SAB R-B 9555

93

Wascana Centre

"I think we can look forward in Saskatchewan to developing a centre here which will be a source of pride, not only for the citizens of Regina but all the citizens of Saskatchewan; just as this legislative building and these grounds have been a source of pride for all our citizens...

"I think Mr. Speaker, we owe a good deal to these people who have gone before us, and we, I think, can repay part of the debt we owe to these people by carrying on their good work in Wascana Centre. We can repay these men and hand down to our children a legislative–university–park area which will continue to be the envy of all Canada."

—*Hon A.E. Blakeney, Provincial Treasurer, Second Reading, Wascana Centre Act, 3rd Session, 14th Legislature, April 6, 1962.*

SAB 94-0336-49

DAVID McLENNAN

DAVID McLENNAN

DAVID McLENNAN

Wascana Lake and the surrounding waterways are located directly under a major North American flyway for migrating waterfowl. In 1913, the marsh and the lake along Wascana Creek were declared a game preserve. The legislative grounds soon became a green oasis on the dry, flat prairie landscape. In 1962, the Legislative Assembly of Saskatchewan passed an Act to create the Wascana Centre Authority, with a long-term plan for the ongoing development of Wascana Park, as it is now known.

Despite occasional criticisms that Wascana Park is "unnatural," filled as it is with trees, shrubs, and grasses that are not indigenous to Saskatchewan, few Regina residents or visitors seem to mind. Those who frequent the park marvel at the waterfowl that have made the park either a resting spot on their long migration or their permanent home. The park has also become a focal point for a variety of activities, from young people playing football on the lawns to families enjoying picnics and barbecues during the summer. The lake, meanwhile, is an attraction for skaters and cross-country skiers in the winter and sailing and rowing enthusiasts during the summer.

JUST WHOSE PARK IS THIS ANYWAY? Ten thousand Canada Geese want to know—that is approximately how many pass through Wascana Park each year. While most head south for the winter, about three to four hundred of their hardy cousins remain behind—a permanent resident flock. But as ubiquitous as the geese are, they are not Wascana Centre's only winged inhabitants. As many as 78 species of birds have been identified breeding in the area of Waterfowl Park—a 223-hectare tract of land and water within the Centre's eastern borders—an undeveloped remnant of native marsh and prairie. So in a sense—Wascana Park is not only for human enjoyment, it is also—well, for the birds.

DAVID McLENNAN

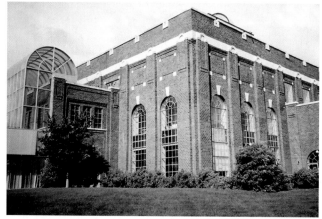

DAVID McLENNAN

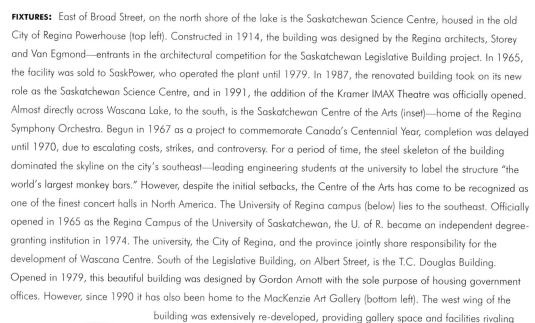

▲ DAVID McLENNAN ▶

FIXTURES: East of Broad Street, on the north shore of the lake is the Saskatchewan Science Centre, housed in the old City of Regina Powerhouse (top left). Constructed in 1914, the building was designed by the Regina architects, Storey and Van Egmond—entrants in the architectural competition for the Saskatchewan Legislative Building project. In 1965, the facility was sold to SaskPower, who operated the plant until 1979. In 1987, the renovated building took on its new role as the Saskatchewan Science Centre, and in 1991, the addition of the Kramer IMAX Theatre was officially opened. Almost directly across Wascana Lake, to the south, is the Saskatchewan Centre of the Arts (inset)—home of the Regina Symphony Orchestra. Begun in 1967 as a project to commemorate Canada's Centennial Year, completion was delayed until 1970, due to escalating costs, strikes, and controversy. For a period of time, the steel skeleton of the building dominated the skyline on the city's southeast—leading engineering students at the university to label the structure "the world's largest monkey bars." However, despite the initial setbacks, the Centre of the Arts has come to be recognized as one of the finest concert halls in North America. The University of Regina campus (below) lies to the southeast. Officially opened in 1965 as the Regina Campus of the University of Saskatchewan, the U. of R. became an independent degree-granting institution in 1974. The university, the City of Regina, and the province jointly share responsibility for the development of Wascana Centre. South of the Legislative Building, on Albert Street, is the T.C. Douglas Building. Opened in 1979, this beautiful building was designed by Gordon Arnott with the sole purpose of housing government offices. However, since 1990 it has also been home to the MacKenzie Art Gallery (bottom left). The west wing of the building was extensively re-developed, providing gallery space and facilities rivaling those in even the largest cities in Canada. In the northeast corner of the park, at the intersection of Albert Street and College Avenue, is the Royal Saskatchewan Museum (centre left). A provincial Golden Jubilee project, the museum was officially opened in 1955 by Governor General Vincent Massey. However, the museum's origins date back to 1906, when the Province of Saskatchewan—not yet a year old—began to take steps to preserve its heritage. First located in the Regina Trading Company building on South Railway Street (see page 5), the museum was relocated in 1911 to the near-completed Legislative Building. In 1916, the museum again moved—to the Regina Normal School building, where it remained until settling into its present location. An interesting and little-known fact is that the foundations of the ill-fated Grand Trunk Pacific Hotel, the *Chateau Qu'Appelle*, lie beneath the museum's front lawns.

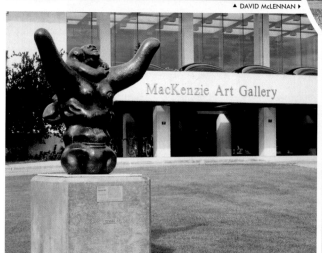

DAVID McLENNAN LEAH BELTECK

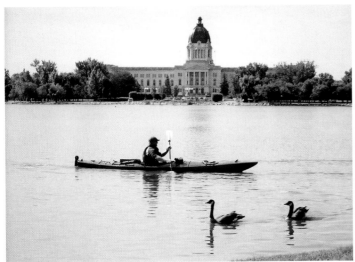

DAVID McLENNAN

VISTAS: Within the park's borders, which extend from Albert Street and College Avenue in the northwest to Fleet Street and the farm lands southeast of the city, great care has been taken to ensure that the skyline is dominated by trees and not buildings. The exception, of course, is the dome of the Legislative Building, seen above from the north shore of the lake and, below, from the Trafalgar Overlook. No building, either within the park proper, or within the surrounding neighbourhoods, may be built higher than the treetops (or 13 metres). The photograph to the right, showing the flowerbeds in front of the building, the lake, and the city beyond was taken from the top of the dome in the summer of 2002.

DAVID McLENNAN

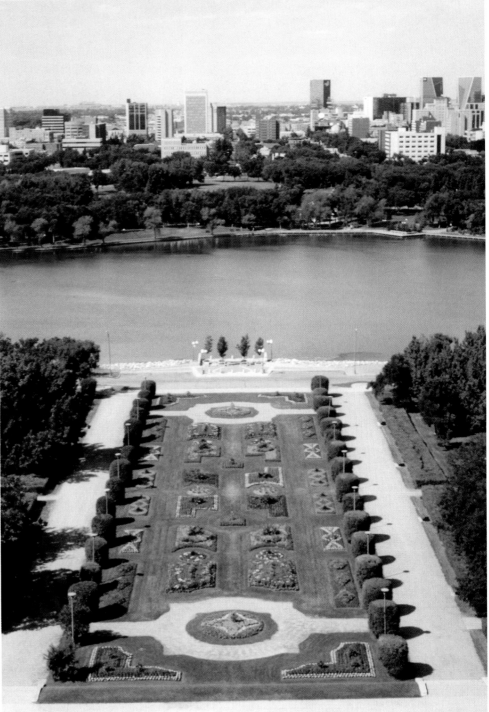

DAVID McLENNAN

▲ DAVID McLENNAN ▲ ▼

MORE WALK, LESS TALK: Throughout Wascana Centre an extensive network of trails has been established. From the new bridge beside the pond and fountain located at the Trafalgar Overlook (above left) to the picnic areas behind the museum (below) is a pleasant walk along the lake's north shore. East of Broad Street, one can stop for a rest at Candy Cane Park (center), or in winter, take to one of the trails popular for cross-country skiing (right). Those choosing the company of four-footed friends are encouraged to tidy up after their canine companions (top center).

DAVID McLENNAN DAVID McLENNAN

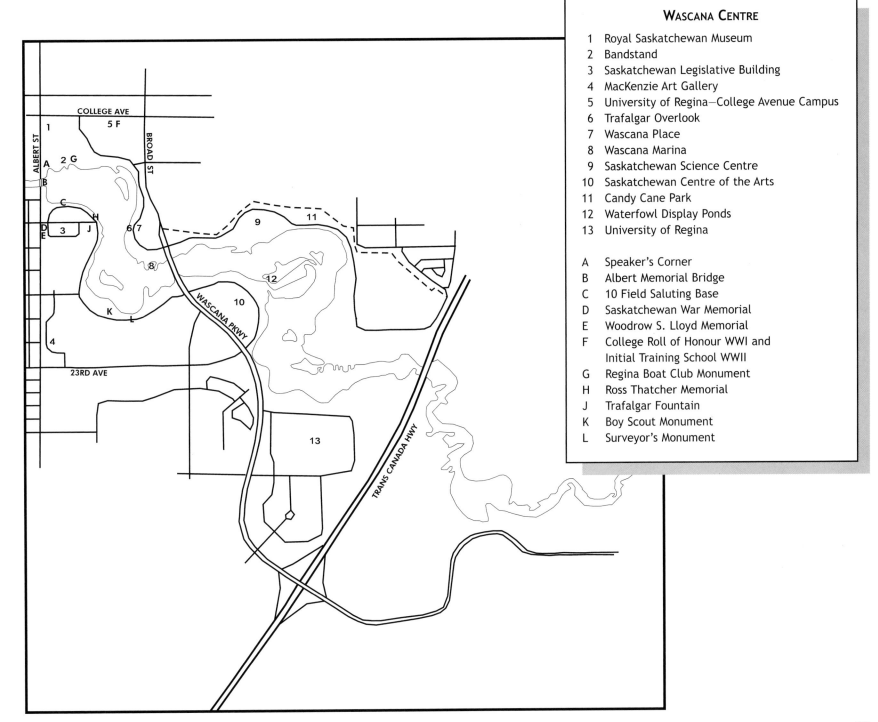

WASCANA CENTRE

1 Royal Saskatchewan Museum
2 Bandstand
3 Saskatchewan Legislative Building
4 MacKenzie Art Gallery
5 University of Regina—College Avenue Campus
6 Trafalgar Overlook
7 Wascana Place
8 Wascana Marina
9 Saskatchewan Science Centre
10 Saskatchewan Centre of the Arts
11 Candy Cane Park
12 Waterfowl Display Ponds
13 University of Regina

A Speaker's Corner
B Albert Memorial Bridge
C 10 Field Saluting Base
D Saskatchewan War Memorial
E Woodrow S. Lloyd Memorial
F College Roll of Honour WWI and
 Initial Training School WWII
G Regina Boat Club Monument
H Ross Thatcher Memorial
J Trafalgar Fountain
K Boy Scout Monument
L Surveyor's Monument

Monuments

Throughout Wascana Park—tucked beneath trees, alongside a winding pathway, by the side of the lake—memorials, monuments, and markers acknowledge those whose courage, strength, vision, and resolve built, not only this province, but also this country. In these places of quiet dignity, the stone, bronze, and brick monuments stand indeed as reminders of accomplishments or sacrifices in the past, but perhaps more importantly, they will serve to inspire countless generations in the future.

Ypres
Festubert and Givenchy
St. Eloi Craters
Mount Sorrel
Somme
Vimy Ridge
Scarpe
Hill 70
Passchendaele
Amiens
Arras
Canal du Nord and Cambrai
Valenciennes

DAVID McLENNAN ▶

LEST WE FORGET: A war memorial commemorating the soldiers from the 28th North West Battalion who died in World War I (1914–18) and those of the 1st Battalion of the Regina Rifle Regiment who were lost in World War II (1939–45) is located immediately to the west of the Legislative Building and adjacent to Albert Street (below; inset at left, detail of the World War I memorial inscription).

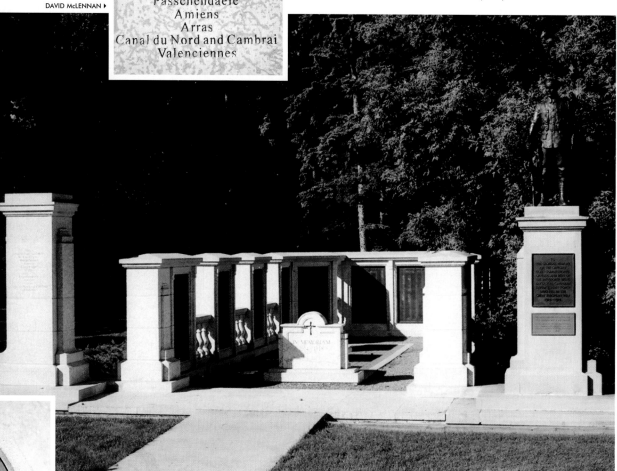

DAVID McLENNAN

SALUTING BASE: The bronze circular plaque set into the top of the centre cement bollard north of the flower gardens marks the saluting base for the Regina garrison artillery unit. From this base, gun salutes have been fired for every sitting of the Legislative Assembly opened by the Lieutenant Governor and on certain national holidays. It was not until July 1, 1983, that the long service of the saluting battery was finally recognized by the unveiling of this small monument.

DAVID McLENNAN

WOODROW LLOYD MEMORIAL: A bench and memorial to Woodrow Lloyd (premier from 1961 to 1964) is nestled in the trees (far right). It is said that Mr. Lloyd, MLA for Biggar from 1944–70, used to walk from his home to the Legislative Building every day and would cut through the trees at this particular point. A commemorative plaque listing dates of importance in Mr. Lloyd's life and political career accompanies the bench. The plaque (inset, right) also includes the Robert Frost poem, "The Road Not Taken."

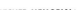

DAVID McLENNAN

DAVID McLENNAN

THATCHER MEMORIAL:

On the east side of the Legislative Building, on the shore of the lake, is a circular cairn (left) in honour of W. Ross Thatcher (premier from 1964 to 1971). The plaque carries the following inscription: "Each man must play his role however great or small in the service of his country. He must give of his energy and wisdom, his love and dedication, to ensure that all people may live together in dignity and in peace.... He remained true to his fundamental belief in the enterprising spirit of the individual man and in the need for a political and social framework that respects and nourishes that spirit."

DAVID McLENNAN

SPEAKER'S CORNER is a monument to our heritage as a democratic society, a tribute to those who have upheld our right to freedom of speech and freedom of assembly. Located off of Albert Street, at the entrance to the park at 19th Avenue, Speaker's Corner was dedicated to the people of Saskatchewan on April 12, 1966, by Earl Mountbatten, Admiral of the Fleet of Burma during World War II. The speakers' podia upon the circular plaza are from the columns of Regina's old City Hall (1906-1965) and symbolize the right to free speech at the municipal level. The Tyndall stone accents create a tie to the Legislative Building across the lake. The two large lanterns at the main entrance to the plaza originally stood at the entrance of the first Speaker's Corner, in Hyde Park, London, England. Ten gas lamps surrounding the perimeter come from King Charles Street near the British Houses of Parliament. And the six paper birch trees were transplanted from Runnymede Meadow near Windsor Castle—where King John signed the Magna Carta on June 15, 1215.

DAVID McLENNAN

DAVID McLENNAN

THE BOY SCOUT MONUMENT (above) is located on the south side of Wascana Lake, west of the abutment of the Old Broad Street Bridge. In 1965, the monument was dedicated in honour of the contribution made by the Boy Scouts in fifty years of scouting in Saskatchewan. The centrepiece of the monument bears the Boy Scout motto—"Be Prepared"—while the smaller surrounding cairns are each engraved with a word describing the desired attributes of a scout.

THE REGINA BOAT CLUB MONUMENT (left) was erected by the Wascana Centre Authority in 1971 to commemorate one of the city's early institutions. The inscription on the marker (inset) tells the story. It reads: "THE REGINA BOAT CLUB WAS ESTABLISHED ON THIS SITE IN 1907, PREDATING THE PLANTING OF TREES AND THE CONSTRUCTION OF THE LEGISLATIVE BUILDING. IT HELD THE DISTINCTION OF BEING THE FURTHEST INLAND ROWING CLUB IN NORTH AMERICA AND THE BRITISH COMMONWEALTH. THE CLUBHOUSE WAS IMMEDIATELY REBUILT AFTER IT WAS DEMOLISHED IN THE 1912 REGINA CYCLONE. IN 1947 THE CLUB MOVED TO THE NORTH ISLAND IN WASCANA LAKE. IT WAS DISBANDED IN 1962 AFTER 55 CONTINUOUS YEARS OF ACTIVITY. MEMBERS ENGAGED IN ALL FORMS OF AQUATIC ENDEAVOUR, ESTABLISHING MANY NORTH WEST INTERNATIONAL ROWING RECORDS. A REGINA CREW OF FOUR WON TWO EVENTS AGAINST THE VERY BEST ON THE CONTINENT AT THE 1936 CANADIAN HENLEY."

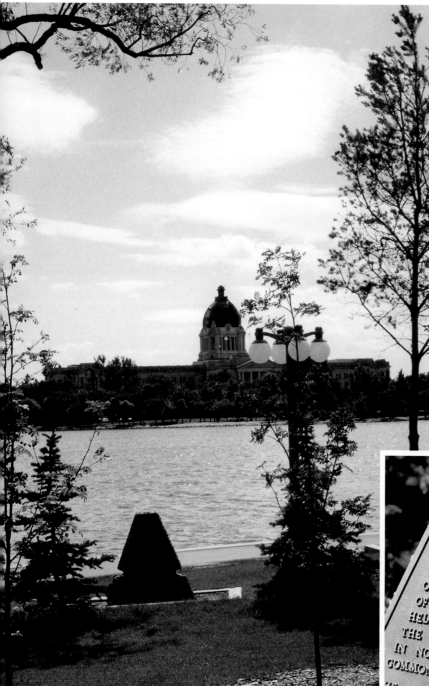

REGINA BOAT CLUB

THE REGINA BOAT CLUB WAS ESTABLISHED ON THIS SITE IN 1907, PREDATING THE PLANTING OF TREES AND THE CONSTRUCTION OF THE LEGISLATIVE BUILDING. IT HELD THE DISTINCTION OF BEING THE FURTHEST INLAND ROWING CLUB IN NORTH AMERICA AND THE BRITISH COMMONWEALTH. HE CLUBHOUSE

DAVID McLENNAN

DAVID McLENNAN

THE SURVEYOR'S MONUMENT (below) was built in 1967 as a Canadian Centennial project. It commemorates the skill, industry, and adventuresome spirit of those who explored and mapped the nation. The monument is comprised of two main parts: the upper part symbolizes—and, in fact, *is*—a surveyor's lookout; the lower part, a sheltered area, is designed to represent a campsite which early surveyors would have used each night as they explored the country. The monument includes a commemorative plaque (left), directional indicators and distances to points across Canada (centre left), and a time capsule sealed in a cairn which contains government documents, a 1967 licence plate and telephone book, flags of Canada and Saskatchewan, samples of wheat, minerals, and oil, and a newspaper headlining the Saskatchewan Roughrider Grey Cup win in 1966. The capsule is scheduled to be opened in Canada's bi-centennial year, 2067.

SURVEYING FOR THE FUTURE

This survey monument and plaque is dedicated to the surveyors of Canada whose skill and industry contributed so greatly to the exploration, mapping and development of our nation.

It is symbolic of the beginning of the second century of surveying in Canada and is a First Post in a united system of precisely co-ordinated survey points.

With eleven other Centennial Survey Monuments erected across Canada, it signifies the contribution by surveyors both past and present to the charting of our nation's future.

DAVID McLENNAN

DAVID McLENNAN

WHITEHORSE -1371.247 MILES

DAVID McLENNAN

A BRIDGE WITH TWO NAMES: Built as a relief effort in 1930, the Albert Memorial Bridge (detail, above right)—commonly known as the Albert Street Bridge—was dedicated at its official opening to those who lost their lives in WWI. It was intended that large bronze plaques bearing the names of the soldiers would be mounted on its pillars. But for reasons unknown this never materialized. Speculation is that with the depression and drought of the 1930s, the plans were "temporarily" shelved, only to be eventually forgotten. By 1988 the bridge was in disrepair, and an initiative was undertaken for its restoration. With the original plans either forgotten or thought to have been abandoned, Regina City Council put forth the idea of placing a plaque on the bridge listing the names of the councillors who had been instrumental in seeing the bridge restored. Veterans cried foul and the new plan was aborted. But this was not the end of the story. A study was subsequently conducted and it determined that the pillars on the bridge could not hold the number of large bronze plaques which would have been needed to bear the names of approximately 5000 war veterans. As it stands, the only names on the bridge are the names of those responsible for its original construction (inset above).

ALBERT MEMORIAL BRIDGE 1930

HON. JAMES F. BRYANT M.A.,LL.B.,K.C.
MINISTER OF PUBLIC WORKS

COLONEL JAMES McARA
MAYOR

PUNTIN, O'LEARY & COXALL
ARCHITECTS & ENGINEERS

CARTER-HALLS-ALDINGER CO.,LTD.
CONTRACTORS

DAVID McLENNAN

CARL SHIELS, SASKATCHEWAN LAND SURVEYORS ASSOCIATION

Centre of Events

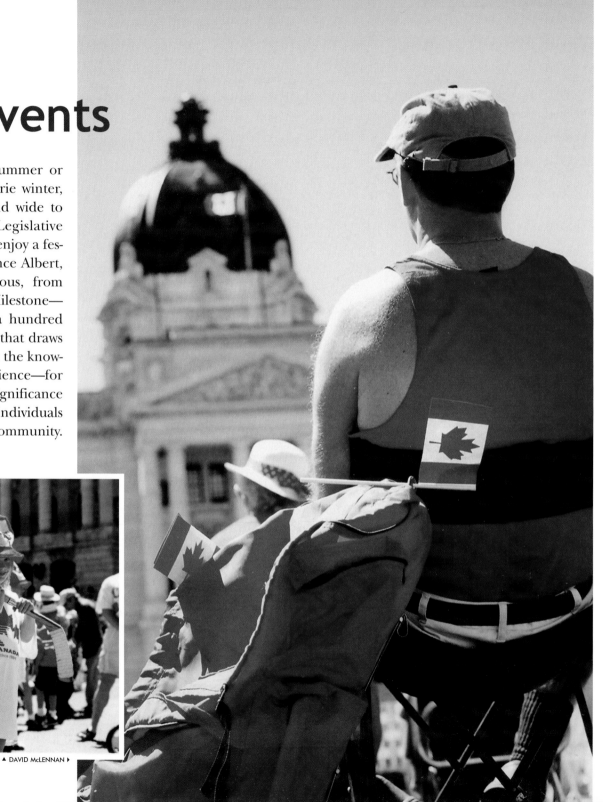

Whether the dog days of summer or the crisp depths of a prairie winter, people come from far and wide to Wascana Park—to the Legislative Grounds—to mark special occasions, to enjoy a festival, celebrate an anniversary. From Prince Albert, from Weekes, from Leader and Watrous, from Maple Creek, Moosomin, Manor and Milestone— they came this year, as they have for a hundred before. It is not so much the event itself that draws us together on these occasions. It is more the knowing that others will be sharing the experience—for what is an event without people? The significance of an event, what makes an event, is that individuals come together, and in doing so, form a community.

▲ DAVID McLENNAN ▶

104

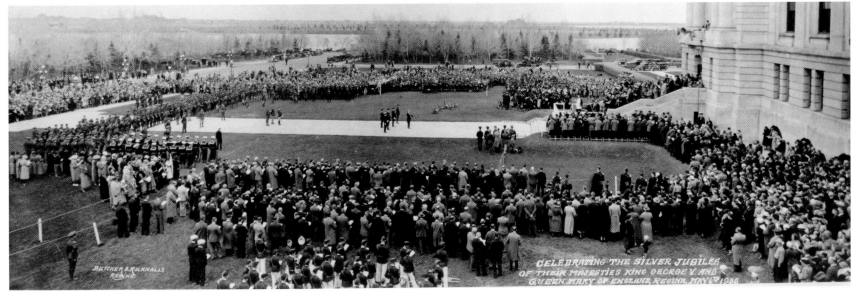

SAB R-D 2091

CELEBRATING THE SILVER JUBILEE OF THEIR MAJESTIES KING GEORGE V AND QUEEN MARY OF ENGLAND, REGINA, MAY 6, 1935

LONG LIVE THE KING: The Silver Jubilee of George V and Queen Mary (above) drew thousands of celebrants to the lawns of the Legislative Building on May 6, 1935. The king's twenty-fifth anniversary on the throne, however, would be his last—the following January the King would be dead, and 1936 would be the year of three kings—George V, Edward VIII, and George VI.

THEY ALWAYS GET THEIR MAN: They don't always get funky. However, this member of the Royal Canadian Mounted Police Bison Band (below left) certainly entertained the crowds in 1987 at the 75th Anniversary of the opening of the Legislative Building.

GUN SALUTE: 10 Field Regiment, Royal Canadian Artillery, fires a gun salute over Wascana Lake in front of the Legislative Building (below). Each year, a gun salute marks Victoria Day in May, Canada Day on July 1, Remembrance Day on November 11, and any other federally or provincially designated occasions, such as special anniversaries. The guns are also fired whenever the Lieutenant Governor arrives at the Legislative Building to open a new session of the legislature.

CANADA DAY CELEBRATIONS take place each year in Wascana Park (facing page). People decked out in red and white, sporting Canadian flags of all sizes, demonstrate that, although often not as overt with their patriotism as some, Canadians love their country second to none. What could be more Canadian than carrying the flag on a good old Sherwood hockey stick?

SAB 87-1202-35

DAVID McLENNAN

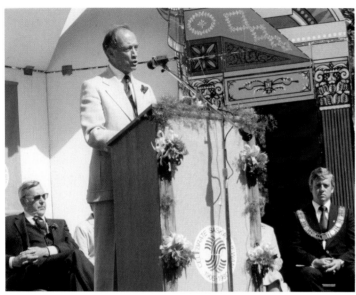

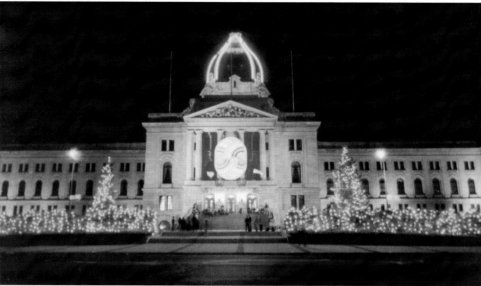

SAB 80-1515-R5-7 SAB CELEBRATE SASK. ALBUM

CELEBRATE SASKATCHEWAN (1980): Prime Minister Pierre Trudeau was one of the province's guests at the 75th anniversary celebrations (above left). Activities in honour of the event included decorating the Legislative Building (above right) and decorating the night sky with fireworks (below left). A double-decker bus (below right)—also decorated—provided tourists and residents with tours around Wascana Centre.

YEARLY EVENTS: (facing page) Pile o' Bones Day, held in mid-summer, is a time for pioneer costumes (bottom right) and pioneer sporting events (top left). Waskimo (the winter festival held in Wascana Centre) is an opportunity for hockey games (top right) and dog sled races (centre); many people simply enjoy the crisp air and winter sunshine on the frozen lake (bottom left). The Legislative Building is traditionally decorated for the holiday season (middle left).

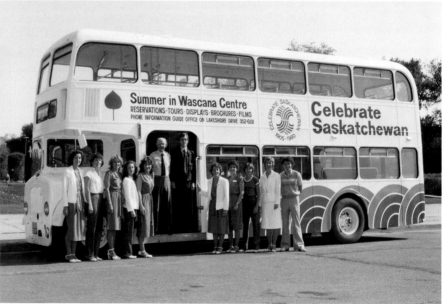

SAB CELEBRATE SASK. ALBUM SAB 80-881-04

SAB 71-762-16

SAB 86-3227-67

◄ DAVID McLENNAN ▲

DAVID McLENNAN

SAB 71-762-10

107

Pomp and Circumstance

"The first train arrived on the morning of August 23, 1882, which was also the occasion for christening the new capital. The first suggestions for the new capital's name were Assiniboia and Leopold, the latter in honor of Queen Victoria's youngest son. However, the Marquis of Lorne, Governor General of Canada, was asked to select a name, and he consulted his wife, Her Royal Highness, Princess Louise, daughter of the Queen. She promptly suggested Regina, signifying queen."

—*W. A. Riddell, recounting the first royal visit to Saskatchewan*

Since 1882, there have been over twenty royal visits to what is now Saskatchewan. In nearly every case, the itinerary includes a visit to the Legislative Building. Typically, the Building serves as the host site—the official centre—for entertaining these important visitors to the province. School children, senior citizens, veterans, politicians, and ordinary local citizens gather at the Legislative Building to catch a glimpse of the Queen or "Queen Mum" and perhaps to have a quick word with the important guest. The building itself has become the link between the province and the Crown and stands as a silent reminder of our historic connections with the British Westminster model and with our system of government—a constitutional monarchy.

SAB R-B 3730

PRINCE OF WALES: George V's eldest son, who was to become King Edward VIII in 1936, visited the province in 1919 (above). The photograph is unique in that Premier Martin (centre) "upstages" royalty by standing on the step in front of the Prince—the portrait was composed to compensate for a discrepancy in height between the two men. In 1927, the Prince of Wales would return to Saskatchewan with his brother, the future King George VI.

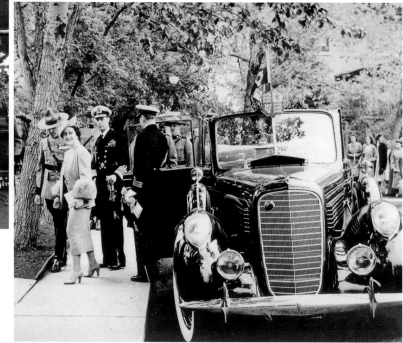

SAB R-B 172

108

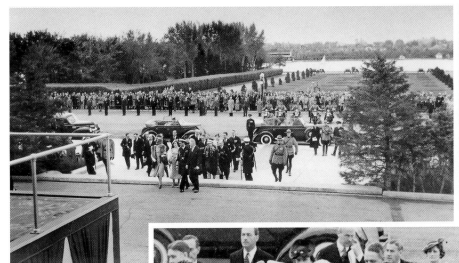

SAB R-A 6485 (2)

KING GEORGE VI AND QUEEN ELIZABETH, parents of our present Queen, enjoyed one of the most successful and well remembered royal visits in 1939. They met with dignitaries at the RCMP Barracks (opposite page, right) and at the Legislative Building (above and inset). Special bunting, large initials for the king, and crowns and

SAB R-A 23881 (1)

provincial coats of arms were in abundance. A dais constructed on the front of the building for the occasion served as the stage for the King, Queen, Lieutenant Governor, Premier Patterson (walking beside the King George V in the photo above), and other important dignitaries (including Prime Minister Mackenzie King shown at far right). This royal visit was remembered most fondly not only because it was the first visit to Canada by a reigning monarch, but also because it came after a decade of depression and drought. The King and Queen traveled by train across Saskatchewan, stopping at various stations to meet with local citizens, their very presence offering new hope and optimism for the province's residents.

PRINCESS ELIZABETH (right, with Premier Douglas) first visited Saskatchewan in 1951, the year before she ascended to the throne. She and Prince Philip have returned to Saskatchewan four more times—in 1959, 1973 (to commemorate the 100th Anniversary of the RCMP), 1978, and 1987.

SAB R-A 8082

109

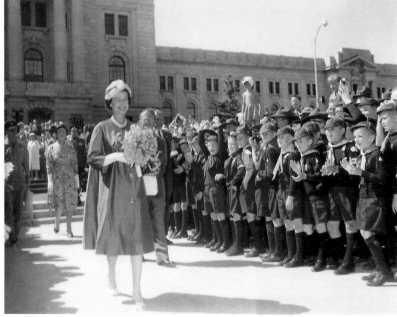

SAB R-A 16148 (1)

BOY SCOUTS AND GIRL GUIDES bring a smile to the Queen's face in 1959 (above). Besides Canada, Queen Elizabeth is also the Head of State to 53 other countries in the Commonwealth.

SAB 82-1018-R8-7A

MEMBERS OF THE ROYAL FAMILY only come to Saskatchewan in response to invitations. In 1982, one such guest was Princess Anne (above, with Premier Devine far right), returning to Canada six years after participating as an athlete in the equestrian events at the Montreal Olympics. Queen Elizabeth, the Queen Mother (lower left), returned to Saskatchewan in 1985, and again appeared before the Legislative Building for an official welcome.

UPON COMPLETION of the four-year building restoration project in 2001, Prince Charles (right, with Premier Calvert) officially opened the new Prince of Wales Entrance, upgrading the building's accessibility standards, enabling people with mobility impairments access to the building's North Wing.

SAB 85-1324-R5-25

ROBERT WATSON, BEAR PHOTOGRAPHY

SAB 87-2121-R15-7

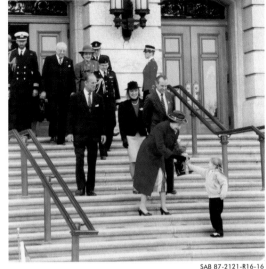

SAB 87-2121-R15-8

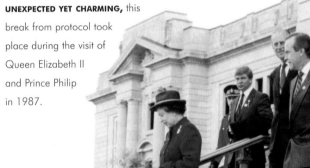

SAB 87-2121-R16-16

SAB 87-2121-R15-9

UNEXPECTED YET CHARMING, this break from protocol took place during the visit of Queen Elizabeth II and Prince Philip in 1987.

SAB 87-2121-R44-12

In Recognition of Distinguished Service...

For their long-standing records of community contribution, the Queen has granted several organizations in Saskatchewan the title "Royal":

- Royal United Services Institute, Regina
- Royal Regina Rifles (reserve infantry unit)
- Royal University Hospital, Saskatoon
- Royal Saskatchewan Museum, Regina
- Royal Regina Golf Club

Princess Anne (the Princess Royal) is Colonel-in-Chief of the Royal Regina Rifles.

Prince Edward (the Earl of Wessex) is Patron of the Globe Theatre, Regina.

Royal Visitors to Saskatchewan since 1950

1951: Princess Elizabeth (the future Queen Elizabeth II) and Philip, Duke of Edinburgh
1958: Princess Margaret (sister of the Queen)
1959: Queen Elizabeth II and the Duke of Edinburgh
1967: Princess Alexandra (first cousin of the Queen)
1973: Queen Elizabeth II and the Duke of Edinburgh
1977: The Duke of Edinburgh
1978: Queen Elizabeth II, the Duke of Edinburgh, and Prince Edward (their youngest son)
1980: Princess Margaret
1982: Princess Anne (daughter of the Queen, now the Princess Royal)
1985: Queen Elizabeth the Queen Mother
1987: Queen Elizabeth II and the Duke of Edinburgh
1989: The Duke and Duchess of York (Prince Andrew, second son of the Queen, and his wife, Sarah Ferguson)
1994: Prince Edward (now the Earl of Wessex)
2001: The Prince of Wales (eldest son of the Queen)

Power to the People

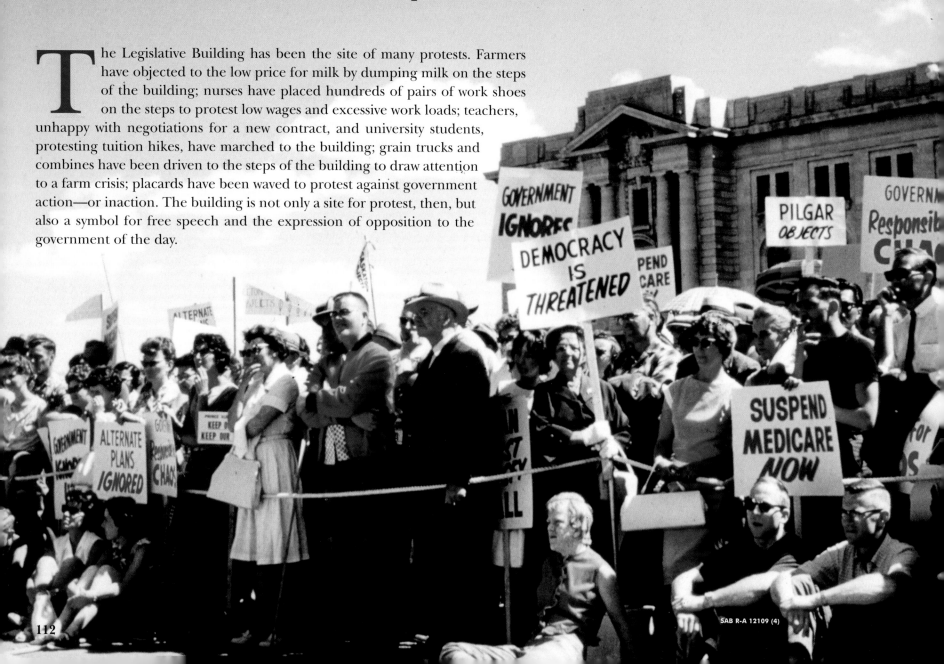

The Legislative Building has been the site of many protests. Farmers have objected to the low price for milk by dumping milk on the steps of the building; nurses have placed hundreds of pairs of work shoes on the steps to protest low wages and excessive work loads; teachers, unhappy with negotiations for a new contract, and university students, protesting tuition hikes, have marched to the building; grain trucks and combines have been driven to the steps of the building to draw attention to a farm crisis; placards have been waved to protest against government action—or inaction. The building is not only a site for protest, then, but also a symbol for free speech and the expression of opposition to the government of the day.

SAB R-A 12109 (4)

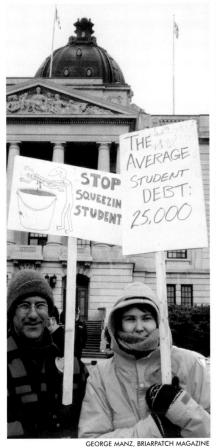

STOP SQUEEZIN STUDENT

THE AVERAGE STUDENT DEBT: 25,000

GEORGE MANZ, BRIARPATCH MAGAZINE

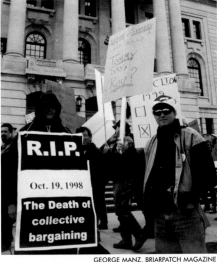

R.I.P.

Oct. 19, 1998

The Death of collective bargaining

GEORGE MANZ, BRIARPATCH MAGAZINE

▲ ADRIANE PAAVO, BRIARPATCH MAGAZINE

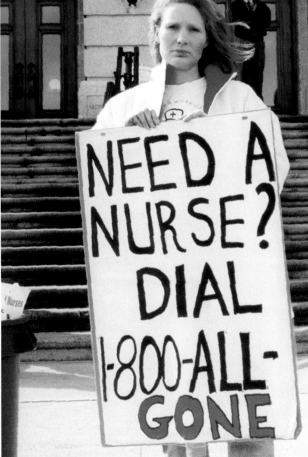

NEED A NURSE? DIAL 1-800-ALL-GONE

GEORGE MANZ, BRIARPATCH MAGAZINE

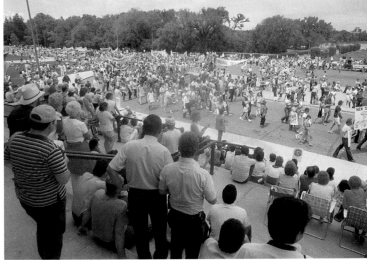

PATRICK PETTIT, LEADER-POST

FACES OF PROTEST: One of the most contentious issues ever in the province was the implementation of medicare in 1962 by the government of Woodrow Lloyd. Doctors and many concerned citizens opposed this measure and marched to the Legislative Building on July 11 to express their disagreement (facing page). The largest political demonstration ever in Saskatchewan took place in June of 1987, when thousands marched to the Legislative Building protesting cut-backs introduced by the government of Grant Devine (lower left). On this page and on the following two pages are additional images of demonstrations against government policies over the years—Saskatchewan people speaking out and marching in protest.

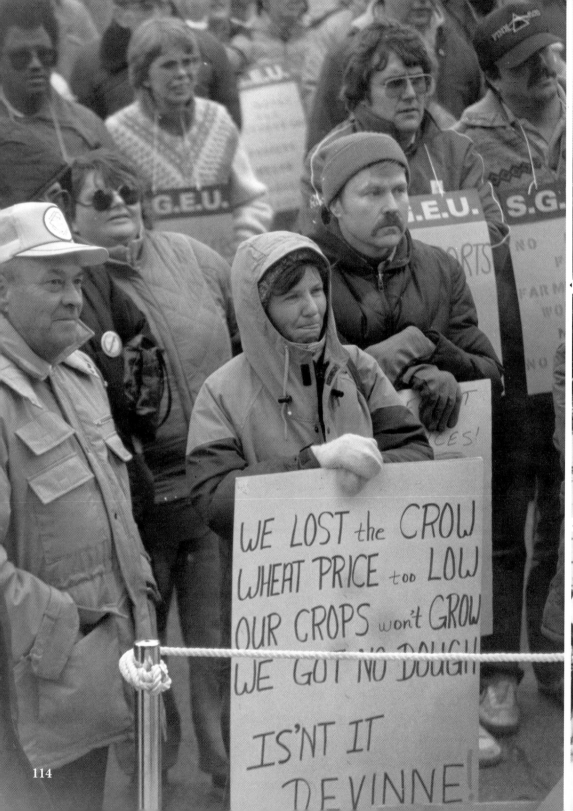

WE LOST the CROW
WHEAT PRICE too LOW
OUR CROPS won't GROW
WE GOT NO DOUGH

IS'NT IT
DEVINNE!

114

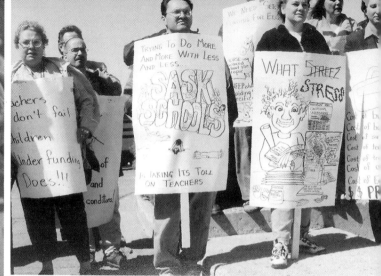

TERRY PUGH, BRIARPATCH MAGAZINE ◀ ▲ BRIARPATCH MAGAZINE

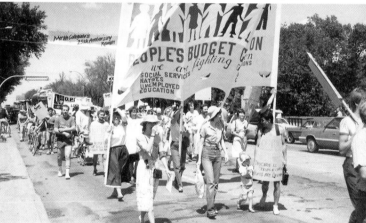

ADRIANE PAAVO, BRIARPATCH MAGAZINE ▼ ▲ LARRY RAYNARD, BRIARPATCH MAGAZINE

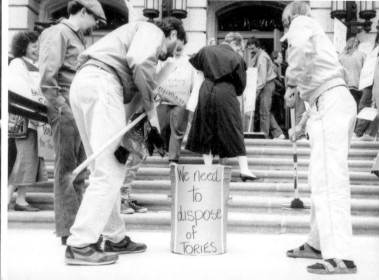

We need
to
dispose
of
TORIES

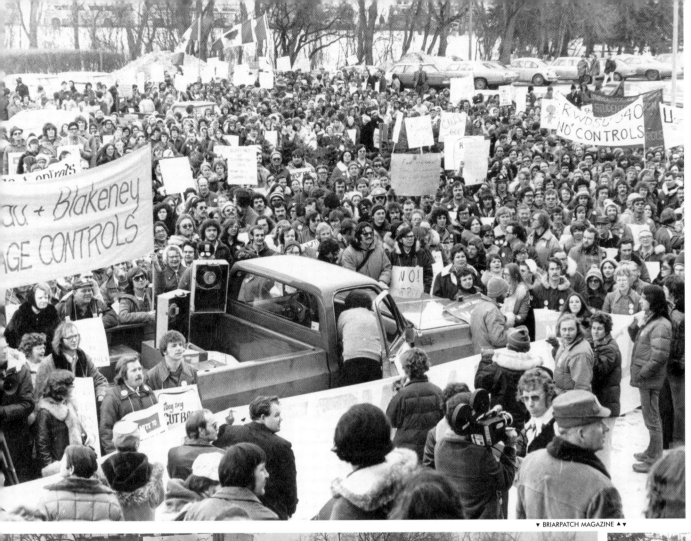

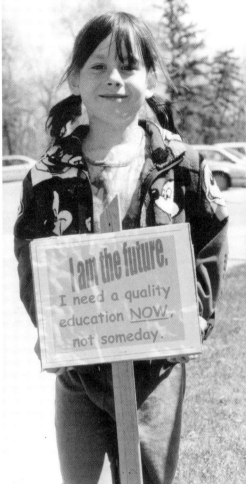

▼ BRIARPATCH MAGAZINE ▲ ▼

▲ GEORGE MANZ, BRIARPATCH MAGAZINE

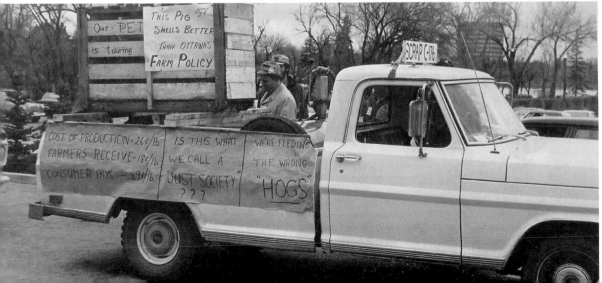

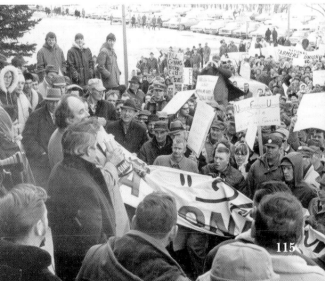

Renovations

"With renovations and additions to accommodate constantly growing needs, how many years may the structure occupy this place which in time will become historic and venerated ground— one century, two centuries, three centuries—who now can tell?"

—*Walter Scott*

SAB 82-1832-04

When the Legislative Building was begun in the first decade of the twentieth century, Walter Scott declared that he wanted a structure that would last at least one hundred years. Nearly one hundred years later, work was underway to strengthen the building's foundations and to renew the building so that it would last another one hundred years. In March 1997, the government of Saskatchewan announced a four-year restoration project that would cost $20 million. Due to changes in soil and moisture conditions under the building, the pilings were no longer supporting the structure adequately. The East, North, and South Wings were settling, causing large cracks in the plaster walls and in the exterior stone work. Major repairs were needed to save the building.

This was not the first renovation project on the building. In the 1960s through to the 1980s, the ground floor was remodeled, the pilings under the West Wing were reinforced, a new air conditioning unit was installed for the Legislative Chamber, and the Chamber itself was refurbished and restored. Over the years, the building was continually upgraded with more insulation, new windows, and television cameras in the Chamber. The control room for the television system was installed in a former broom closet.

In the most recent refurbishment, additional fire doors and a fire sprinkler system have been installed. In order to make the building more accessible, a barrier-free entrance has been created on the north side of the building adjacent to the exterior main staircase.

Despite its numerous renovation projects over the decades, Saskatchewan's Legislative Building looks much now as it did when it was completed in 1912. The traditional fireplaces have been restored; not one of them has been moved or removed. Much of the original furniture has been restored and returned to the building and is back in daily use. Maintaining and restoring such a building is not an inexpensive undertaking. Yet, care has always been taken to retain the integrity of its original design at the same time as modern standards for convenience, efficiency, and safety are achieved. The result is a building that is not only functional and efficient, but also a tribute to those whose vision and planning and labour caused it to be built nearly a century ago.

INTO THE FUTURE: Television cameras were installed in the Chamber in the fall of 1982. The photograph on the facing page, taken on September 24, shows the measures taken to protect the historic room. When the studio (below) became operational, it was the most state-of-the-art broadcast-quality system of its kind. Subsequently, the Saskatchewan Legislative Assembly television system has been a model for legislatures all over the world. Five multi-directional, remotely controlled cameras broadcast the entirety of the House proceedings to centres across Saskatchewan. The videotape becomes a permanent record at the Saskatchewan Archives.

THE WORK NEVER ENDS: Maintaining the building is an enormous task—and even simply applying a new coat of paint can be a major undertaking. Giving the Rotunda a fresh face in 1971 required the erection of scaffolding three stories high (top right). In the 1980s it was discovered that the foundations under the West Wing of the Legislative Building were in dire need of attention. The 600 original piles under the area were showing their age, necessitating that construction crews install new piles to correct the structural deficiencies. Reconstruction of the basement area under the West Wing (below right) was also undertaken at this time.

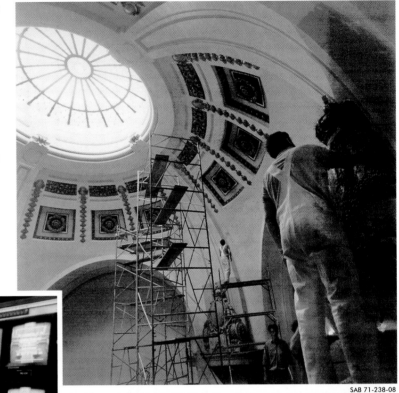

SAB 71-238-08

SAB 85-3065-09 SAB 88-1490-11

117

SAB 83-3057-R3-9

CRACKING UP: Who said political life was easy? After almost ninety years, both the shifting of the building's foundation and Saskatchewan's harsh climate had caused major cracks in the exterior Tyndall stone. As the foundations shifted, cracks formed; water seeped in, froze, and expanded, thus furthering the damage. The photograph above, taken in 1983, shows that even twenty years ago the problem was apparent. By the 1990s, the safety of those working in and around the building was becoming an issue—pieces of the stone were literally falling off of the building. One piece, approximately the size of a dinner plate, and weighing several pounds, had fallen from near the top of the Dome. The solution to the problem was a four-year restoration project which included underpinning the building with nearly 1800 new piles to increase the stability of the foundation and prevent further damage from occurring.

MESSAGE IN A BOTTLE: In October 1997, an engineer examining the building made an unexpected discovery. Tucked away in a dark ceiling cavity above the Legislative Chamber, near the base of the Dome, was a glass bottle with a note inside. Presumed to have contained either alcohol or medicine, the bottle had been left by two plasterers, John McLeish and Frank Chester, who worked for C.W. Sharp & Son of Winnipeg—a sub-contractor working on the original construction project. Payroll records show that these men earned 60 cents an hour and lived at 1832 16th Avenue (now College Avenue), where the Waverly Manor stands today. The message and

DAVID McLENNAN

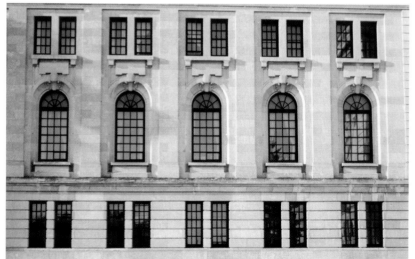

DAVID McLENNAN

the bottle (left) are now on display in the building's entrance. The note was removed from the bottle for examination, and a reproduction was created by the Royal Saskatchewan Museum (above) before the message was placed back in the bottle where it had been hidden for over 86 years. The message reads, "J. McLeish and F. Chester worked on these arches in April 1911. Has been a bad winter lots of people lost in blizzards hope to be home Xmas."

HERITAGE FIRST: During the 1980s, renovating for energy efficiency demanded some creative solutions from planners who knew the importance of preserving the character of the Legislative Building. The first renovation involved lowering the ceilings on the second floor to conserve energy for both heating and cooling. While this would not have affected the interior appearance substantially, it would have drastically changed the building's exterior, since the top section of each window would be darkened (particularly noticeable at night when the interior lights were on). To solve the problem, the architect designed half-moon casings at the tops of the windows—thus, the ceiling is lowered, but the windows remain completely exposed and the light shines out as before. A second challenge occurred when the windows themselves were to be replaced. Large sheets of continuous glass were the most energy-efficient solution, but the building would have a markedly different look without the traditional muntin bars. The solution was to install the modern windows together with artificial muntin bars to preserve the exterior aesthetic.

DAVID McLENNAN

ROBERT WATSON, BEAR PHOTOGRAPHY

The Prince of Wales Entrance

This entrance was officially opened by His Royal Highness The Prince of Wales on April 26, 2001.

The Prince of Wales Entrance was created as part of a rehabilitation project between 1997 and 2001 to ensure the preservation and integrity of the Saskatchewan Legislative Building for future generations.

This barrier-free entrance was designed to ensure accessibilty for all people.

DAVID McLENNAN

CLEAR SAILING: It may be hard to imagine that something as magnificent as Saskatchewan's Legislative Building could be improved—but improved it was! With the opening of the Prince of Wales Entrance in April 2001, persons with mobility impairments could finally access the building through the North (front) Wing. Previously, access could only be obtained at the service entrance around the rear side of the building (inset). His Royal Highness, the Prince of Wales, and Minister Doreen Hamilton officially presided at the ribbon-cutting ceremony (above). Steven Ripplinger (right), then a fourteen-year-old student at Miller High School, cut the ribbon and was the first to use the new entrance.

DAVID McLENNAN

ROBERT WATSON, BEAR PHOTOGRAPHY

"Century after century..."

"What a field for speculation is opened by this occasion—what unlimited room for imagination in the thought of history which will be made in this building, the history which will centre here and which in both the figurative and literal sense, this building will share in and preserve!"

—Excerpt from the speech Walter Scott prepared for the building's opening ceremonies, but unfortunately was never able to give.

As the Province of Saskatchewan approaches its centennial year, the words of its first premier, T. Walter Scott, writing nearly a century ago, are in some ways remarkably optimistic, yet in other ways, remarkably prophetic. Speaking at the cornerstone ceremony in 1909, Premier Scott knew that the construction of the Legislative Building was a special event in the history of the province:

How many thousands of feet may climb these stairs in this entrance in the years to come—carrying a burden of responsibility as legislators, one long continuous line of them, year after year, generation after generation, century after century—the trusted, invaluable administrative officials and experts and staffs, contemporaneous lines of them, generation succeeding generation—studious or merely curious processions of spectators and visitors, week after week, year after year. What countless numbers of eyes will scan the brief record on this stone commemorating this day?

Scott's generation had a grand vision of what the province would become. By 1925, the province had the third largest population in the Dominion and the future looked bright indeed. But the founders of Saskatchewan had foreseen neither the drought nor the depression of the 1930s. These events changed the direction of the development of the province forever, and Saskatchewan did not grow into the most powerful province in Canada as had been expected.

Yet for nearly one hundred years, Saskatchewan's Legislative Building, described as one of the most beautiful buildings in North America, has stood tall and gracious—a majestic building in a majestic land.

SAB 88-0913-32

SAB 90-600-09

References

The William Cullen Bryant quotation on page 2 is from Morris and Isabel Dolman eds., *Easy Travel: A Traveller's Guide to Saskatchewan* First Edition (Regina: Easy Travel Guides) • The map of Fort Livingstone on page 2 is from John Hawkes, *The Story of Saskatchewan and Its People, Vol. 1* (Chicago: S.J. Clarke, 1924) • The Walter Scott quotation on page 4 is from Saskatchewan Archives Board (SAB), Walter Scott papers, Walter Scott to C.A. Semans, November 17, 1910, 41087 and Walter Scott to J.A. Aikens, May 30, 1910, 50349 • The map on page 8 showing site options for the new Legislative Building is adapted from Brennan, *Regina: An Illustrated History*, page 72 and Rodney E. Laporte, "The Development of Parks in Regina, 1882–1930: Private Initiative and Public Policy", unpublished thesis, 1984, 78 • The James Calder quotation on page 9 is from SAB, Dept of Public Works files # 119G, folder "Grounds-Legislative Building-Purchase of Site and Improvement of Grounds," Calder to Scott dated June 14, 1906, p. 4 • The Walter Scott quotation on page 11 is from SAB, Dept of Public Works files # 195.2, Walter Scott to F.M. Rattenbury, November 1, 1906 • The F.J. Robinson quotation on page 11 is from SAB, Dept of Public Works files, #R195-118-75, Robinson's specifications for the building, May 22, 1906 • The quotation on page 11 regarding the relationship of the architectural firm of Sproatt and Rolph to the Liberal Party is from SAB, Dept of Public Works files, #R195-118073, Reverend D. Oliver to Walter Scott, September 9, 1907 • The Darling & Pearson quotation on page 13 is from SAB, Public Works files #R 195-315, Darling and Pearson to Walter Scott, December 4, 1907 • The quotations from the Maxwell brothers' Architect's Report on pages 15, 36, 48, 53, and 55 are from *Canadian Architect and Builder*, Vol. XXII, No. 2, pages 11–14 • The Walter Scott quotation on page 27 is from SAB, Walter Scott papers, 52551. Excerpt of Scott's speech at laying of cornerstone, October 4, 1909 • The Duke of Connaught quotation on page 42 is from W.A. Riddell, *The Origin and Development of Wascana Centre* (1992), p. 47 • The Walter Scott quotation on page 43 is from SAB, Walter Scott papers, Walter Scott to Charles Lunn, June 25, 1909, 9085 • The Captain John Palliser and Sir John A. Macdonald quotations on page 86 are from Ronald Rees, "Wascana Centre: A Metaphor for Prairie Settlement," *Journal of Garden History*, vol. 3, no. 3, 219-232 • The quotation on page 90 is from Marguerite E. Robinson, *History of Wascana Creek Development,* quoted in *Wascana Worlds* • The map of Wascana Centre on page 99 is adapted from *Wascana Centre 1999 Master Plan.* • The quotation on page 108 is from Riddell, *Regina: from Pile of Bones to Queen City of the Plains*, p. 20 • The Walter Scott quotation on page 116 is from SAB, Walter Scott papers, 52351, Cornerstone Ceremony address, October 4, 1909 • On page 120, the first Walter Scott quotation (from the speech that was not delivered) is from Riddell, *The Origin and Development of Wascana Centre*, p. 47; the second Walter Scott quotation (from his address at the cornerstone ceremony) is from SAB, Walter Scott papers, 52351 •

Selected Bibliography

SOURCES FOR GENERAL HISTORY OF THE PROVINCE:

Archer, John. *Saskatchewan: A History.* Saskatoon, Western Producer Prairie Books, 1980.

Wright, J.F.C. *Saskatchewan: The History of a Province.* Toronto: McClelland and Stewart, 1955.

SOURCES FOR GENERAL HISTORY OF REGINA:

Argan, William with Pamela Cowan. *Cornerstones: An Artist's History of the City of Regina.* Regina: The Leader-Post Carrier Foundation Inc., 1995.

Brennan, J. William, ed. *Regina Before Yesterday: A Visual History 1882 to 1945.* Regina: City of Regina, 1978.

Brennan, J. William. *Regina: An Illustrated History.* Toronto and Ottawa: James Lorimer & Company, Publishers, Canadian Museum of Civilization, 1989.

Drake, Earl G. *Regina: The Queen City.* Toronto: McClelland and Stewart, 1955.

Riddell, W.A. *Regina: from Pile O'Bones to Queen City of the Plains: An Illustrated History.* Burlington: Windsor Publications, 1981.

SOURCES FOR GENERAL HISTORY OF WASCANA CENTRE:

Riddell, W.A. *The Origin and Development of Wascana Centre.* 1992.

Wascana Centre Authority. *Wascana Worlds.* 1972.

Wascana Centre Authority and Du Toit Allsopp Hillier. *Wascana Centre 1999 Master Plan.* 1999.

SOURCE FOR INFORMATION ABOUT WALTER SCOTT:

Barnhart, Gordon. *Peace, Progress and Prosperity: A biography of Saskatchewan's first premier, T. Walter Scott.* Regina: Canadian Plains Research Center, 2000.

SOURCES FOR GENERAL INFORMATION ABOUT THE LEGISLATIVE BUILDING:

Barnhart, Gordon. *Sentinel of the Prairies: The Saskatchewan Legislative Building.* The Province of Saskatchewan, 1987.

Legislative Assembly of Saskatchewan. *Legislative Building.*

SOURCE FOR INFORMATION ABOUT THE LEGISLATIVE LIBRARY:

MacDonald, Christine. *The Legislative Library of Saskatchewan: A History.* Regina: Saskatchewan Legislative Library, 1986.

SOURCE FOR INFORMATION ABOUT PROVINCIAL SYMBOLS AND EMBLEMS:

Jackson, Michael. *Images of a Province: Symbols of Saskatchewan.* Regina: Government of Saskatchewan, 2002.

SOURCE FOR INFORMATION ABOUT ROYAL VISITS TO SASKATCHEWAN:

Jackson, Michael and Wendy Campbell. *Saskatchewan Royal Reflections: The Prince of Wales in Saskatchewan, April 2001.* Regina: Government of Saskatchewan.